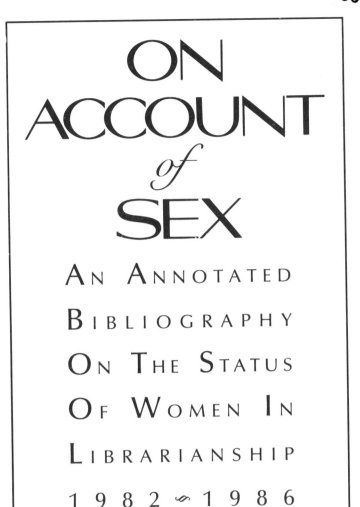

ON ACCOUNT *of* SEX

AN ANNOTATED BIBLIOGRAPHY ON THE STATUS OF WOMEN IN LIBRARIANSHIP 1982 ∽ 1986

KATHARINE PHENIX, LORI GOETSCH,
SARAH WATSTEIN, AND MARY ELLEN H. LANDRY
FOR THE COMMITTEE ON THE STATUS OF WOMEN
IN LIBRARIANSHIP
AMERICAN LIBRARY ASSOCIATION

AMERICAN LIBRARY ASSOCIATION
CHICAGO AND LONDON 1989

Cover designed by Jim Lange

Text composed by ALA Books on a BestInfo Wave4 pre-press
system and output on an L300 laser printer

Printed on 55-pound Glatfelter B-31, a pH-neutral stock, and
bound in 65-pound Mohawk Tomohawk cover stock by Versa Press, Inc.

The paper used in this publication meets the minimum requirements of American National
Standard for Information Sciences—Permanence of Paper for Printed Library Materials,
ANSI Z39.48-1984. ∞

Library of Congress Cataloging-in-Publication Data

On account of sex : an annotated bibliography on the status of women
in librarianship, 1982-1986 / Katharine Phenix . . . [et al.] for the
Committee on the Status of Women in Librarianship, American Library
Association.
 p. cm.
 Continues: On account of sex : an annotated bibliography on the
status of women in librarianship, 1977-1981 / Kathleen Heim and
Katharine Phenix.
 ISBN 0-8389-3375-0
 1. Women in library science--United States--Bibliography. 2. Sex
discrimination against women--United States--Bibliography. 3. Sex
discrimination in employment--United States--Bibliography. 4. Women
in information science--United States--Bibliography. 5. Women
information scientists--United States--Bibliography. 6. Women
librarians--United States--Bibliography. I. Phenix, Katharine,
1952- . II. Heim, Kathleen M. On account of sex. III. American
Library Association. Committee on the Status of Women in Librarianship.
Z682.4.W65052 1989
016.02′082--dc20
 89-36547

CONTENTS

PREFACE

A bibliography of the scope of *On Account of Sex* calls up the question, "Is it worth it?" Would not standard indexing services provide adequate information on most items relating to the careers and status of women in library and information science? The answer, of course, is a resounding No! As the introduction demonstrates, many issues integral to the progress of women in the profession are not addressed by indexing terms and would elude the bibliographic net if the bibliographers had not read and analyzed the literature of the field with attention to these concerns. Through a daunting attack on the voluminous literature, Katharine Phenix, Lori Goetsch, Sarah Watstein, and Mary Ellen Landry have provided a cogent and lucid survey of all items pertinent to the status of women.

Do we still need this meticulous documentation? You bet we do! As this volume was going to press, the U.S. Supreme Court heard arguments intended to dismantle the right to reproductive freedom gained in the 1973 *Roe vs. Wade* decision. At the same time, Felice Schwartz's January 1989 *Harvard Business Review* article on corporate response to maternity turned over the rock of pent-up anxiety toward women who have children at mid-career and initiated national discussion of the "mommy track."[1] Also as this volume was going to press, library women had not made strong gains in positions or power commensurate with their numbers in the profession.

If women do not achieve parity in a profession in which they are the majority, it is crucial that members of the profession seek to understand the root causes. Baseline data continue to be developed. The 1988 Library and Information Science Students' Attitudes, Demographics, and Aspirations (LISSADA) Survey of more than 3,000 master's students enrolled at accredited programs of library and information science includes a chapter on gender. According to this study, women were older than male students (median age was 36 vs. 34), were more likely to be married (55.2% vs. 38.4%), held fewer subject masters (17.9% vs. 29.4%), and were less mobile (13.7% vs. 28.7%).[2] Putting these facts together with the career development and/or career progression studies identified in

this bibliography will help us to determine what variables might be altered. We need all this information to address problems and barriers in order to overcome them.

On Account of Sex provides women in librarianship with information about their professional status and saves time in building comparable-worth arguments. It provides new entrants with a concise orientation to the enduring sociological factors that get in the way of parity. This book "arms" library women with the facts and discussions needed to organize for change. It is an important contribution to understanding the social and economic reasons that mitigate against equality and equity.

Kathleen M. Heim, Dean
Louisiana State University
School of Library and Information Science
co-editor of *The Role of Women in Librarianship* and
On Account of Sex, 1977-1981

1. Felice N. Schwartz, "Management Women and the New Facts of Life," *Harvard Business Review* (Jan.-Feb. 1989):65-76.

2. Kathleen M. Heim and William E. Moen, "Gender," in *Occupational Entry: Library and Information Science Students' Attitudes, Demographics, and Aspirations Survey* (Chicago: American Library Assn., 1989).

ACKNOWLEDGMENTS

Many thanks and much credit go to Louisiana State University (LSU) and the School of Library and Information Science, its dean, Kathleen M. Heim, and its librarian, Alma Dawson, for their donation of time, research assistants, resources, and support. Mary Catherine Politz at the Interlibrary Loan Department of the Middleton Library at LSU also deserves credit for her work on our behalf, as does David Judell for his hard work on the project. Dr. Norman Horrocks was a dedicated contributor to the bibliography by providing citations from the Australian contingent of feminist librarians. Margaret Myers also deserves special mention for her tireless efforts on behalf of the Committee on the Status of Women in Librarianship, and most especially for her patience with computer incompatibility.

<div align="right">Katharine Phenix</div>

To Carrie Mannas, the most profound thanks for typing, clerical and moral support, to members of the Hunter College Reference Division, who were good enough to listen to my ongoing commentaries about the diverse and often elusive literature on the status of women in libraries; to Joan Levinstein for many bowls of emotional chicken soup; and to Lee Cardamone for her enthusiastic support and tolerance for 3x5 cards, 4x6 cards, and the dreaded three Ls—legal pads, legal pads, legal pads.

Heartfelt thanks also to Katharine Phenix for her invaluable assistance every step of the way.

<div align="right">Sarah Barbara Watstein</div>

Thanks to Marty Courtois, my partner in life, for his support.

<div align="right">Lori Goetsch</div>

INTRODUCTION

Five years after Kathleen Weibel and Kathleen M. Heim compiled *The Role of Women in Librarianship 1876-1986: The Entry, Advancement, and Struggle for Equalization in One Profession* (Oryx Pr., 1979), *On Account of Sex: An Annotated Bibliography on the Status of Women in Librarianship 1977-1981* was published (American Library Assn., 1984). The passing of another five years has led to the production of this work. In the short span of fifteen years, a few compilers thus have made it possible to consult these three volumes to delve into 110 years of writings reflecting the participation and status of women in librarianship, from 1876 to 1986. The Committee on the Status of Women in Librarianship (COSWL) is already supporting the research that will contribute to another demidecade (1987-1991) of bibliographical work that will maintain this careful collection of citations. Why is this work being done? What has changed, and what are the new directions taken by feminist librarians in the last five years?

Their research potential is the foremost purpose of the bibliographies. Clearly, the consistent underrepresentation of women, who are the majority of librarians throughout the world, in top administrative positions in major institutions and associations is cause for concern and closer study. Many writers discuss the gender-stratified nature of librarianship and hypothesize controlling variables for the condition, but nobody has yet found the direct route to equality for women in libraries. Bibliographical control in this field will expedite the literature search and provide raw material from which the researcher may extract more data or explore new possibilities.

The parameters of this bibliography have remained the same as previous ones. Any study of students, faculty, reference librarians, library directors, or other groups of library and information science-related individuals that characterizes the group by gender is described. Sometimes this may mean annotating a single line in a single table that breaks out a group of librarians by sex. Moreover, each of the annual statistical articles and essays, such as the *Library Journal* series on "sex and salaries" and "placements and salaries," is collected, as are relevant National

Center for Education Statistics (NCES) publications and annual statistical reports of organizations and associations such as the Association of Research Libraries and the Association for Library and Information Science Education. The *ALA Yearbook of Library and Information Services* is analyzed for reportage of ALA activities of interest on women in libraries. Conference reports of all library and information science associations that describe activities and presentations of note to researchers on the status of women in libraries are included and annotated. Because future scholars of the history of women in librarianship will be interested in the formation of numerous women's groups and caucuses within library associations, these activities, publications, and meetings have been documented as well. Of course, all major research specifically on the status of women in librarianship has its place in this bibliography, and critical reviews of several research studies are included.

Although the amount of published work on women in libraries in this time period remains roughly equal to that of the previous five years, the nature of the information has changed slightly. The 1977-1981 time period has been characterized as a period of activism. The Equal Rights Amendment was a major issue taken up by librarians during that time, and *On Account of Sex* not only tracked debate about boycotting nonratified states, but also recorded the reports of ALA Chapter Councilors in their state journals and newsletters on the debate, thereby revealing the personal insights of some of the individuals during this tumultuous period. Only the vote to end the boycott is reported in the current time period, and no other single issue has since incited similar activism.

The growing literature on comparable worth is more evident in this collection than in its predecessors even though much of the published material on comparable worth remains outside the scope of the bibliography. Some articles and news notes have been included as representative of the current economic struggle of a "feminized" profession. Other timely materials include citations relating to individual cases as they represented intellectual struggle within the profession, such as the Glenda Merwine case, to the extent that the issue involving Merwine was perceived as a sex discrimination issue rather than a challenge to the master's in library science (MLS) degree.

A new body of substantive research on women in libraries is taking shape, as evidenced by Heim's collection of essays in her *Status of Women in Librarianship* [1983-11A-O]; Irvine's monograph *Sex Segregation in Librarianship* [1985-09] also falls into this category, as do the Heim and Estabrook report *Career Profiles and Sex Discrimination in the Library Profession* [1983-10] and the fall 1985 issue of *Library Trends* titled "Women and Leadership in the Library Profession" [1985-80A-I]. These are examples of scholarly works only hoped for a decade ago.

International material on women in libraries continues to be elusive. Although new links are forged occasionally by individuals, formal collaboration among women's groups in libraries in even English-speaking countries such as Canada, Australia, and Great Britain is not forthcoming. The *Library Association Record*

provided a special issue on women in libraries in August 1985 [1985-79A], but reaction to it, even in England, was lukewarm. Other European librarians are almost completely left out of the bibliography, and what we know about African women librarians is provided by only one male author. Undoubtedly, current international events, including a 1988 International Federation of Library Associations and Institutions (IFLA) preconference on women, will be reported in the literature and subsequently be picked up by a future bibliography.

The Introduction to the earlier edition of *On Account of Sex* focused on the women's movement within librarianship from 1977 to 1981, specifically on organized activity for equality and status gains within both ALA and other large associations and organizations. In the final section, the future for women in libraries was discussed. Career development and comparable worth were highlighted as two major fronts on which the profession was attacking the problem of the depressed status of women librarians.

In the years 1982-1986, career development continued to be viewed as a positive action to gain women entrance into the power positions in the profession. An overview of the existing literature of this period also shows that, side by side with continuing attention to career development, increasing attention was paid to career progression. A new realism had seeped into the women-in-libraries literature. Emphasis had shifted from static documentation of women on the bottom rung of the career ladder to the provision of pragmatic formulas for individual success. Even in the absence of formalized career development and assessment centers for women, the new focus was and remains on self-improvement and achievement.

Career Development

How are women introduced to the profession? What influences their career choices? And what has librarianship done and not done for women interested in becoming librarians? These questions are addressed in several articles that look at women's career and educational choices by examining factors related to the potential appeal of librarianship as a profession. These factors include library and information science education, salaries, work environments and work schedules, career counseling, and sex roles in the profession.

Both the past and the present of library and information science education have been studied, from Brand's "Sex-Typing in Education for Librarianship: 1870-1920" [1983-11C] to Harris's "Career Aspirations of MLS Students" [1986-58]. In between lie many other discussions of the effects of library education and educators on attracting and mentoring women entering the profession: Reeling [1983-11E], O'Brien [1983-11D], and Dewey [1985-63] look at recruiting, while Moriearty and Robbins-Carter [1985-80I] consider the impact of role modeling in library and information science education. Even undergraduate librarian education is discussed in Schmidt's "The Other Librarians" [1984-53].

Finally, Maack [1986-101], Beghtol [1986-55], and Harris, Mitchel, and Cooley [1985-97] examine the status of women library educators and students and what impact that has on the profession.

Salaries and work environment have also been considered influential factors in the selection of librarianship as a career. Besides the annual placements and salaries data reported by Carol Learmont and Steven Van Houten in *Library Journal* and the overwhelming number of articles on comparable worth and sex discrimination, such articles as "Avoid Librarianship, Ambitious Women Advised" [1982-45], McGraw's "Poverty Wages for Women" [1984-71], and Dowell's [1986-03] dissertation on sex and salary point to the continuing disparity between female and male librarians' income. Van House [1984-110] also uses data to project into the future of the profession and to document the impact of supply and demand on women's salaries.

Work environment is examined from a number of different angles. For example, a variety of career options is explored in Sellen and Vaughn's "Alternative Careers for Librarians" [1985-17], and flextime opportunities are discussed by Shank [1984-109]. Lynch and Verdin [1983-83], Greear [1982-87], Smith and Reinow [1984-54], and Rockman [1984-101] examine quality of work life and job satisfaction. Even child-care concerns are raised, as in Dymke's "Professional and Parent: Maintaining the Balance" [1986-85].

Several articles discuss career planning and counseling for librarians, both for those beginning in the profession and for those considering a career change. "Career Development Needs and Plans" [1984-74], "Centers for Career Help Proposed" [1984-50], "Career Mapping and the Professional Development Process" [1984-14B], and "Career Change Opportunities Discussed at WPAC Seminar" [1982-91] report the growing demand for such assistance. Also, practical articles such as Ward's "Working Your Way Up the Ladder" [1984-27G] provide strategies for career advancement. Finally, the status of the reentry woman is considered by Dickson [1983-11O].

Career Progression

It is important to distinguish between career development and career progression. The former may be seen as a process that involves thinking, planning, and making decisions about careers. It requires awareness of the world in which women live, experiencing work-related activities, developing interests and values, increasing their self-knowledge, investigating careers, and making a series of educational and career choices. Career progression is more than the choice of a career line. It, too, is a process, one that involves both navigating among career supports and barriers, developing and expanding one's work-related roles, and achieving positions of power and responsibility. While career development can be seen as the creation and maintenance of a career package, career progression can be seen as the expansion and furthering of such a package. The latter involves

asking three questions: Where am I? Where am I going? How do I plan to get there? Both career development and progression can be measured with respect to employment and earnings. However, while career development can be measured against starting positions, salary, and status, career progression is measured by second, third, or fourth positions, salary, and status.

Attention to career progression for women in library and information science is reflected by themes that recur in article after article from 1982 to 1986. It is documented first and foremost by the preponderance of articles that profile who is at the top and address such questions as these: What are the significant features of those in this strata? What traits or abilities are exhibited by individuals or groups at the top? Can this group be drawn in outline? What can we learn from this exercise?

Mech [1982-109; 1984-68; 1985-49] and Tierney and Mech [1985-33] conducted a number of studies of library directors of small colleges by region. Karr [1984-90] and Wong and Zubatsky [1983-44] also profiled academic library directors. Academic library administration was examined generally by Zipkowitz and Bergman [1982-40], Moore [1983-65], Anderson [1985-22], Green [1984-81], and Irvine [1985-09]. Focus on women in academic library administration is provided by Fennell [1983-11I], Moran [1983-78], and Ivy [1984-11]. Characteristics of library school deans are discussed by Kilpela [1982-54], and those of women in public library administration are revealed by Greiner [1985-80G].

In addition to articles profiling those at the top, we see career progression themes in numerous articles specifically on women as managers and women in library management. (Indeed, in many instances, women in management emerges as a secondary theme in the articles previously mentioned.) Clarenbach [1982-37F]; Ritchie [1982-31]; Weingand [1982-37A]; Fennell [1983-11I]; Morris [1983-33]; Rhodes [1983-11H]; Frontain [1984-06]; Maggio [1984-82]; Antolin [1985-02]; Brandehoff [1985-23]; Swisher, DuMont, and Boyer [1985-80E]; and Person and Ficke [1986-10] all address this topic. The fall 1985 issue of *Library Trends*, edited by DuMont and titled "Women and Leadership in the Library Profession" [1985-80A-I], contains ten articles on this theme.

Attention to career progression is also evidenced by the number of works concerned with three additional subjects: (1) the skills, abilities, and factors that make possible or influence the rise to the top; (2) career paths and career patterns; and (3) sex structuring and status differentiation.

What skills and abilities are necessary to get to the top? This question was examined by Ward [1982-20E; 1984-27G], Lumpkin [1983-56], and Olsgaard [1984-46]. A related question, that of the factors that influence the rise to the top, was also posed. In 1982 Ferriero [1982-42] offered one answer to this question in his study "ARL Directors as Protégés and Mentors." Fulton [1983-71] examined the search committee's influence on the access of minorities and women to administrative leadership positions, Robinson [1983-11M] and Nzotta [1984-48] both looked at geographic mobility, and Posey [1983-21] reviewed mentoring of

library directors and career advancement. Schuman [1984-47] considered power, and Ivy [1984-11] focused on identity, power, and hiring, while Swisher, DuMont, and Boyer [1985-80E] concentrated on motivation as a factor.

Continuing interest in the role and potential of career development and assessment centers in career progression was documented by Durrance [1982-52], Melber and McLaughlin [1982-24; 1985-57], Wood and Hamilton [1982-95], and Hiatt [1983-41; 1983-42]. Career paths and patterns were the concern primarily of Irvine [1982-15], Futas [1983-11N], Greiner [1984-07], Koenig and Safford [1984-114], Saunders [1984-24], Tinsley [1984-14B], and Bierman [1985-101].

Finally, interest in career progression is shown by the amount of work on sex structuring and status differentiation. Martin [1983-11J], Sharma and Wheelock [1983-76], Swisher and DuMont [1984-69], Kempson [1985-79D], and Moore and Kempson [1985-29; 1985-55] focused on the former theme, and Heim [1982-37B] and Etaugh [1985-04], on the latter.

We cannot help but wonder if there will be a new wave of social activism in the 1990s to counteract the current period of ponderous legislation in comparable-worth action and the introspective emphasis on personal aspiration? Will the next five years be the final five years of differentiating the careers, the salaries, and the status of librarians by sex? Or will the feminist bibliographers of the future continue to publish annotated lists of findings of sex discrimination in the profession?

Bibliography Content and Organization

More emphasis than in the past has been placed on retrieving government documents and dissertations in this time period, and some census material has been included as well. Nothing of major importance was found to add to the previous time periods, as was done in the 1977-1981 edition of *On Account of Sex*.

The bibliography is organized by date, and within dates by type of publication, and within type of publication alphabetically by main entry. For example, the year begins with all monographs arranged alphabetically by the authors' last names. Following the monographs are those works that are published monthly, then the weeklies are added in chronological order. The quarterly publications fall between the relevant months (fall before September, winter before December, spring before March, and summer before June). In this way, items are listed in somewhat the same order as they might have been released. The individual articles in special issues of journal publications are cited in page number order rather than alphabetically. An identification number composed of the year of publication and sequence within that year has been assigned to each item with the exception of letters in response to articles, reviews, and editorial comment. These are indented and entered below the item to which they pertain, first by date then alphabetically by author. If letters generate other letters, additional sequences are identified by further indentation and entered below the letters to which they refer. On a few

occasions where a work is related to a previous listing, we have referred to citation numbers in the two previous volumes, *On Account of Sex 1977-1981* and *The Role of Women in Librarianship 1876-1976*. An asterisk (*) in front of a citation means it was not available for annotation. The annotations themselves are meant to provide enough information for the reader to determine whether the item is worth retrieving for perusal. They were not written as complete abstracts.

In this volume, the practice of annotating reviews of major monographs has, for the most part, been dropped, since it is likely that the actual reviews rather than an interpretation of the reviews will be of more interest to someone who is interested in the reviews. A few newspaper articles are included if deemed to provide major coverage. Except in very special cases, articles that deal with only one woman who did something commendable are not included. Also excluded are articles in publications devoted to women in libraries, such as the Social Responsibilities Round Table (SRRT) Feminist Task Force publication *Women in Libraries* or the British *WILPower*. Material that is available in two formats—printed and in fiche—or in a journal and also in a collection of works is usually cited in both formats so that if one format is unavailable, the other may be attained. This is especially true of Educational Resources Information Center (ERIC) documents. Also for ease of access and retrievability, Dissertation Abstract International (DAI) numbers and American Statistics Index (ASI) numbers have been included when and where available. It should be clear that many of the items cited here were found through painstaking perusal of the shelves and the periodicals themselves, as the information in much of this material is not readily evident by means of standard indexing and abstracting methods, although, of course, standard library and information science reference tools were useful for the more obvious items.

The ALA Headquarters library continues to serve as a clearinghouse for the actual documents cited here, and they are available through interlibrary loan.

ANNOTATED BIBLIOGRAPHY

1982-01A Bidlack, Russell E. "Faculty." In *Association of American Library Schools Library Education Statistical Report 1982*. State College, Pa.: Assn. of American Library Schools, 1982.

Ninth report in Faculty Report series includes information on percentage of full-time faculty members who are female (Table 1-3); changes in male-female full-time faculty ratio (Table 1-4); beginning salaries, broken down by sex for assistant professors (Table 1-11a); distribution by sex of salaries for new assistant professors (Table 1-12); and comparison of average faculty salaries for males and females in sixty-seven Association of American Library Schools (AALS) member schools. Also compares male and female faculty promotions (Table 1-21), breaks down by sex earned doctorates held by faculty members (Table 1-22), gives information on tenure status by rank and sex (Table 1-26a), gives sex breakdown of faculty by geographic region (Table 1-26c), and compares faculty salaries by sex and by region (Table 1-26d).

1982-01B Learmont, Carol L. "Students." In *Association of American Library Schools Library Education Statistical Report 1982*. State College, Pa.: Assn. of American Library Schools, 1982: S1-S91.

Includes information on enrollment by program and sex, based on students officially enrolled in the fall 1981 term, and gives a profile of the student body by program levels, including number of students by sex and ethnic origin and number of students by age and sex. Also includes information on scholarships and assistantships awarded by amounts, sex, and program levels for the fiscal year 1980-1981. Master's students enrolled full time in the fall 1981 term totaled 752 men and 2,810 women at the sixty-nine library schools reporting. At the doctoral level, there were eighty-four men and 113 women in the twenty-four schools reporting.

1

***1982-02** Bourne, Vanessa; Hill, Michael; and Mitcheson, Barrie. *Library and Information Work.* 2 vols. Sydney: Library Assn. of Australia, 1982.

Review:

Rochester, Maxine K. "Who Are We?" *Australian Academic and Research Libraries* 13 (December 1982): 249-253.

1982-03 Burlingame, Dwight F., and Repp, Joan. "Factors Associated with Academic Librarians' Publishing in the 70s: Prologue for the 80s." In *Options for the 80s: Proceedings of the Second National Conference of the Association of College & Research Libraries.* Edited by Michael D. Kathman and Virgil F. Massman. Greenwich, Conn.: JAI Pr., 1982: 395-404.

Study of two groups of academic librarians—authors and nonauthors—attempts to characterize publishing activity. Table 1 "Academic Librarians Distribution by Sex" (p. 398) breaks down distribution by sex. Consistent with previous findings, women authors are published less than men: 41.9 percent women to 55.2 percent men.

1982-04 Coe, Mary Jordan. "Personnel and Employment: Compensation." In *ALA Yearbook 1982.* Edited by Robert Wedgeworth. Chicago: American Library Assn., 1982: 204-208.

Summarizes salary surveys, some of which are broken out by sex, done of ALA, Special Libraries Association (SLA), ARL, and public librarians. The Library Activist Workers strike in San Jose and the general issue of pay parity are mentioned.

1982-05 Dickinson, Elizabeth M. "Is Affirmative Action Dead?" In *ALA Yearbook 1982.* Edited by Robert Wedgeworth. Chicago: American Library Assn., 1982: 209-210.

Notes in particular pay equity and sexual harassment issues in regard to affirmative action plans.

1982-06 Eckard, Helen. *Statistics of Public Libraries 1977-1978.* Washington, D.C.: Natl. Center for Education Statistics, 1982. (ED 1.122/2: 977-78) (4858-7 ASI 1982)

Section on library staff notes that women comprised 84 percent of the professional staff of public libraries and showed a growth of 6.2 percent. The number of male professionals has increased 12 percent since 1974 (p. 2). Table 2 displays professional staff by sex for public libraries serving populations of 100,000 or more (pp. 41-57).

1982-07 Fretwell, Gordon. *ARL Annual Salary Survey 1981.* Washington, D.C.: Assn. of Research Libraries, 1982.

Continues reports of salaries by sex and ethnic background. With this volume, ARL switched year of reporting. Table 13 shows that in most categories men earn more than women and continue to hold the preponderance of top positions.

1982-08 Grant, W. Vance, and Eiden, Leo J. *Digest of Education Statistics 1982*. Washington, D.C.: Govt. Print. Off., 1982. (ED 1.113: 982) (4825-2.16 ASI 1982)

Data are provided on average salaries of administrative staff, including chief librarian, in institutions of higher learning for 1976-1977, broken down by sex (Table 100, p. 109). Information on bachelor's, master's, and doctoral degrees conferred in 1979-1980 by sex of student and field of study (Table 108, p. 120); data on associate degrees—including library associate—conferred in 1979-1980 by sex (Table 123, p. 136); and data for 1973-1974 and 1978-1979 on men and women in school media centers are also provided (Table 178, p. 198).

1982-09 Heim, Kathleen M. "A Bibliography of Demographic, Occupational, and Career Pattern Characteristics of Professional Women, with a Special Emphasis on Those in the Library and Information Fields." Chicago: American Library Assn., Committee on the Status of Women in Librarianship, n.d.

Bibliography accompanying the American Library Association Committee on the Status of Women in Librarianship's ALA Goal Award Project: "A Career Profile of the American Library Association," is thirty-one typed pages of items relating to librarianship, occupational segregation, job mobility, and other issues affecting library career patterns.

1982-10 Heim, Kathleen M. "The Demographic and Economic Status of Librarians in the 1970s, with Special Reference to Women." In *Advances in Librarianship*, vol. 12. Edited by Wesley Simonton. New York: Academic, 1982: 1-45.

Summarizes present knowledge of the demographic characteristics of librarians and information-related professionals, paying special attention to the status of men and women. Includes tables from graduate and placement studies and from association and institutional surveys. Gains in starting salaries are weighed against losses for women when experience becomes a variable.

1982-11 Heim, Kathleen M. "Women and Minorities in Academic Libraries." Arlington, Va.: ERIC Document Reproduction Service, 1982. (ED 208 888)

Summarizes and analyzes data from 1975-1976 College and University Personnel Association Administrative Compensation Survey. Findings indicate that white men predominate as head librarians in all institutions except white women's private and minority public and private institutions.

1982-12 Helmick, Aileen Barnett. "Two Cognitive Styles Among Library Science Students: Field Dependence/Independence and Tolerance-Intolerance for Ambiguity." Ph.D. thesis, Florida State University, 1982. (DAI82AAD-29149)

Study of 386 subjects analyzed by sex, among other variables.

1982-13 Hildenbrand, Suzanne. "Women in Librarianship." In *ALA Yearbook 1982*. Edited by Robert Wedgeworth. Chicago: American Library Assn., 1982: 286-289.

Points out three areas of activity regarding the status of women in librarianship in 1981: surveys, education and consciousness-raising, and change-oriented activities. Eight surveys are summarized and described. Educational activities include papers presented at the annual Association of College and Research Libraries (ACRL) meeting, and networking efforts in New York, North Carolina, New England, Indiana, and Illinois. National efforts of the ALA Committee on the Status of Women in Librarianship and work by the Career Development and Assessment Center for Librarians, ALA divisions such as the Library Administration and Management Association's (LAMA) Women Administrators Discussion Group, the Library of Congress's (LC) Women's Program Advisory Committee, and the Society of American Archivists' (SAA) Women's Caucus are noted among the change-oriented activities.

1982-14 Irvine, Betty Jo. "ARL Academic Library Leaders of the 1980s: Men and Women of the Executive Suite." In *Options for the 80s: Proceedings of the Second National Conference of the Association of College and Research Libraries*. Edited by Michael D. Kathman and Virgil F. Massman. Greenwich, Conn.: JAI Pr., 1982: 421-431.

Explores the differences in the career paths of men and women ARL directors. Data based on a survey of 386 ARL administrators (75 percent response rate). Six areas are reviewed: position status and age, career mobility, mentors and other factors influencing career development, educational preparation, involvement in professional organizations, and publication. One interesting finding is that women and men are equally likely to hold elected offices in state organizations; however, more women have held national office.

1982-15 Irvine, Betty Jo. "Female and Male Administrators in Academic Research Libraries: Individual and Institutional Variables Influencing the Attainment of Top Administrative Positions." Ph.D. thesis, Indiana University, 1982. (DAI AAAD82-11346)

The focus of this study was to determine if the disproportionately small number of women in administrative positions in research libraries could be significantly associated with differential demographic and career characteristics of women and men and with differential characteristics of the institutions in which they held executive-level positions. The findings indicated that selected demographic and career variables were associated with female and male attainment of academic library administrative positions, but that there were fewer demographic and career differences by sex than expected.

1982-16 Josephine, Helen. "Pay Parity for Library Workers." In *ALA Yearbook 1982*. Edited by Robert Wedgeworth. Chicago: American Library Assn., 1982: 206-207.

Pay parity, or comparable worth, is defined and differentiated from the concept of equal pay for equal work, followed by a short history of comparable-

worth studies in libraries. Legislation, programs and conferences, and publications on comparable worth are described.

1982-17 Land, R. Brian. "Canadian Correspondent's Report." In *ALA Yearbook 1982*. Edited by Robert Wedgeworth. Chicago: American Library Assn., 1982: 297-303.

Under the subheading "Equal Pay for Work of Equal Value" (p. 298), comparable-worth complaints taken to the Canadian Human Rights Commission are described.

1982-18 Lawson, A. Venable. "Library Education." In *ALA Yearbook 1982*. Edited by Robert Wedgeworth. Chicago: American Library Assn., 1982: 112-115.

Summarizes statistics reported in the Association of American Library Schools' second Library Education Statistical Report for 1981 on graduates and placement and faculty.

1982-19 Learmont, Carol L., and Van Houten, Stephen. "Placements and Salaries, 1980: Holding the Line." In *Bowker Annual*. 27th ed. New York: Bowker, 1982: 273-287.

Continues annual salary survey. Reports mean salary for men ($14,917) and for women ($14,071). Data are displayed in twelve tables. Adaptation of [1981-120].

1982-20A "Positive Action: Women in Libraries Second Annual Conference." *Librarians for Social Change* 10, no. 1 or no. 28 (1982): whole issue.

Reprints text of speeches given at the second annual conference on women in libraries.

1982-20B Jesperson, Sherry. "Women in Libraries Second Annual Conference—Positive Action." *Librarians for Social Change* 10, no. 1 or no. 28 (1982): 3-4.

Positive action is used as a broader translation of *affirmative action*. Suggests four main areas: trade union support, new and flexible working hours, special training for women, and eradication of sexist material.

1982-20C Coote, Anna. "Positive Action: An Introduction." *Librarians for Social Change* 10, no. 1 or no. 28 (1982): 5-7.

Describes two major pieces of legislation: the Equal Pay Act of 1970 and the Sex Discrimination Act (1975). Suggests that more programs are needed to effect "positive action," such as "Girls into Science and Technology" (GIST). Sets out steps necessary to set up a positive action committee, using general examples of women in workplace situations.

1982-20D Ball, Elizabeth. "Positive Action for Women in Employment." *Librarians for Social Change* 10, no. 1 or no. 28 (1982): 8-12.

Reports results of an "action-research" project at Thames Television designed to look at equal opportunities within the organization.

1982-20E Ward, Patricia Layzell. "Positive Action for Women in Libraries." *Librarians for Social Change* 10, no. 1 or no. 28 (1982): 19-20.

Offers action checklists on getting women into positions of influence in libraries. Five checklists mark stages in a library career, starting with library school and concluding with counteracting sexism in libraries.

1982-20F "Women in Libraries: The First Eighteen Months . . . and the Future." *Librarians for Social Change* 10, no. 1 or no. 28 (1982): 21-22.

Concluding section collectively edited by members of Women in Libraries recounts the activities of the group, assesses its impact (they write, "judging from the jibes in the *Library Association Record* and *New Library World*, some men in the field are feeling very threatened by the idea of women getting together to challenge this male-dominated profession"), and describes future projects.

1982-21 Lockwood, James D. "Library Statistics of Colleges and Universities in the Pacific Northwest, 1980-81." Corvallis, Ore.: Pacific Northwest Library Assn., Academic Division, in cooperation with the Interinstitutional Library Council, Oregon State System of Higher Education, 1982.

Observations accompanying Table 2, "Sexual Composition of Professional Library Workforce," include work force by percent (56.4 percent women, 43.6 percent men), sex of library director (35.3 percent women, 64.7 percent men), and comparison among work force and directorships of private and public universities (p. 29).

1982-22 Mallory, Mary. *Directory of Library and Information Profession Women's Groups.* 2d ed. Chicago: American Library Assn., 1982.

A central source of addresses, contact persons, meeting dates, and purposes of library profession women's groups. Includes ALA and its various subsections on women's issues (COSWL, ERA Task Force, LAMA Women Administrators' Discussion Group, Reference and Adult Services Division (RASD) Women's Materials and Women Library Users' Discussion Group, and the SRRT Feminist Task Force). Also includes other national associations, foreign associations, and associations in individual states. See [1981-94] for annotation of the first edition.

1982-23 Maxin, Jacqueline A. "Managerial Job Satisfaction, Perceived-Achievement-Job-Climate, and Need for Achievement in Libraries." Ph.D. thesis, University of Pittsburgh, 1982. (DAI 8321450)

Study investigates the interaction and relationship between job satisfaction, perceived-achievement-job-climate, and the need for achievement, and the relationship of these three areas to seven demographic variables. Findings were that

those in high-achievement job climates were more satisfied than those in low-achievement climates, and that men were less satisfied than women.

1982-24 Melber, Barbara D., and McLaughlin, Steven D. "Evaluation of the Librarian Career Development and Assessment Center Project." Seattle, Wash.: Battelle Human Affairs Research Centers, 1982.

Provides in-depth analyses of the characteristics of the participants (e.g., responses to questions relating to perceived reasons for the underrepresentation of women in management) (p. 18, Table 6). Emphasis is on evaluating direct effects on participants' attitudes and behavior. Concludes that the Center has been "successful in its objective of providing individual development assistance to assessees of all skill levels To the extent that the program both sensitizes managerial level librarians to the issue of women's status in the profession and improves observational skills and behavior based on evaluation of performance, career advancement of women librarians may be enhanced through changes in the assessors' approach to hiring and promotion at their places of work."

1982-25 Miksa, Francis. "The Interpretation of American Public Library History." In *Public Librarianship: A Reader*. Edited by Jane Robbins-Carter. Littleton, Colo.: Libraries Unlimited, 1982: 73-90.

Comparison of writings on public library history includes comments on Dee Garrison's *Apostles of Culture* and her treatment of the "feminization" of the American public library movement.

1982-26 Minner-Van-Neygen, Veerle. "Students' Attitudes Towards the Behavioral Approach to Library and Information Sciences: An Experiment Involving the Group as an Agent of Change." Ph.D. thesis, University of Pittsburgh, 1982. (DAI 8303581)

Analysis of data in this study, which was intended to develop and test a training design that would modify library science students' attitudes toward a behavioral approach in library and information science and to examine predictors of such an attitude, reveals that there is a significant correlation between sex and resistance to the behavioral approach to library and information science.

1982-27 Moran, Barbara Burns. "Career Progression of Male and Female Academic Library Administrators." Ph.D. thesis, State University of New York at Buffalo, 1982. (DAI AAD82-14211)

Analysis of career progression of 320 academic librarians over a ten-year period identifies professional characteristics associated with achieving a library directorship. Determinants of success are compared for males and females and suggest the existence of two career patterns. The typical male pattern showed acquisition of professional credentials, participation in professional organizations, publishing, and geographical relocation enabling males to obtain a directorship; whereas the typical female pattern showed directorships achieved through internal promotion and rising through the ranks.

Review:

Heim, Kathleen. *Library and Information Science Research* 5 (Fall 1983): 327-329. Positive descriptive review, but notes two shortcomings: lack of attention to the earlier literature on this topic and failure to consider the total social context of the problem studied.

***1982-28** Musmann, Victoria Kline. *Women and the Founding of Social Libraries in California, 1859-1910.* Ph.D. thesis, University of Southern California, 1982.

Findings show that women established social libraries in 63.4 percent of the cities surveyed. Concludes that women led the social library movement in California and that their success convinced local governments to establish free public libraries.

1982-29 Nyren, Karl. "LJ News Report, 1981." In *Bowker Annual.* 27th ed. New York: Bowker, 1982: 3-5.

See [1982-43].

1982-30 Phornsuwan, Saangsri. "The Influence of Socio-Economic Background, Education, and the Appraisal of Librarianship in Choosing Librarianship as a Career by Academic Librarians in Thailand." Ph.D thesis, University of Pittsburgh, 1982. (DAI AAD83-17303)

Study on university librarians in Thailand reveals that 91 percent of academic librarians with low rank and salaries are female.

1982-31 Ritchie, Sheila. "Women in Library Management." In *Studies in Library Management.* Edited by Anthony Vaughn. London: Clive Bingley, 1982: 13-36.

Notes that the majority of the library profession in the United Kingdom (women) become a very scarce minority in higher seniority levels. Tables show percentages of men and women in top levels: Level One contained 105 men and three women in 1981 (p. 14). Author also investigates "leaving patterns" of men and women, and findings show that women are less likely to stay in the profession during the first seven years of their careers, but men are twice as likely to leave during their second seven years. Professional activity, qualifications, aspirations, managerial qualities, and education of UK librarians are all described. Author offers some reasons for women's low status and concludes that librarianship "must be a microcosm of the social world in which it operates, and that society is changing and so must the profession."

1982-32 Selden, Catherine; Mutari, Ellen; Rubin, Mary; et al. *Equal Pay for Work of Comparable Worth: An Annotated Bibliography.* Chicago: American Library Assn., Office for Library Personnel Resources, 1982.

Booklet contains a general introduction and 142 annotated citations to comparable-worth materials.

1982-33 Sink, Darryl L. "Employment Trends for Educational/Instructional Media Graduates." In *Educational Media Yearbook 1982.* Edited by James W. Brown and Shirley N. Brown. Littleton, Colo.: Libraries Unlimited, 1982: 69-74.

Tenth annual study of employment trends for graduates of educational and/or instructional media programs notes that the number of women graduates has continued to grow. Totals (Table 2 "Educational/Instructional Technology Degree Production 1980-81") are 640 women to 361 men. No other data are broken out by sex.

1982-34 Smith, Karen F. "The Sabbatical Option: Who Exercises It?" In *Options for the 80s: Proceedings of the Second National Conference of the Association of College and Research Libraries.* Edited by Michael D. Kathman and Virgil F. Massman. Greenwich, Conn.: JAI Pr., 1982: 451-461.

Comparison of librarians who do or don't take sabbaticals finds that males are overrepresented (48.9 percent) in the sabbatical group and make up only 36.4 percent of the nonsabbatical group.

1982-35 U.S. Congress. House Joint Committee on Post Office and Civil Service. Subcommittees on Human Resources, Civil Service Compensation, and Employee Benefits. *Pay Equity: Equal Pay for Work of Comparable Value.* 2 vols. 97th Cong., 2d sess., 1982. Pts. 1 and 2.

Testimony of immediate past-President of the American Library Association, Elizabeth Stone, and additional documents (pp. 575-596).

1982-36 U.S. Equal Employment Opportunity Commission. *Minorities and Women in Public Elementary and Secondary Schools, 1979 Report.* Washington, D.C.: Govt. Print. Off., 1982. (Y3.Eq2: 12-3-979) (9244-4 ASI 1982)

Annual report for 1979 on employment of minorities and women in elementary and secondary public schools. All data are broken out by sex. Audiovisual librarian is considered a full-time staff job category. Tables are included for the United States, each state, and various-size enrollment groups.

1982-37A Weingand, Darlene E. "Women and Library Management: The Challenge." In *Women and Library Management: Theories, Skills, and Values.* Edited by Darlene E. Weingand. Ann Arbor, Mich.: Pierian, 1982: 1-3.

Describes the theme of the conference "to seek the elusive elements which lead to the effective merging of women and management in library and information science."

1982-37B Heim, Kathleen M. "Factors Contributing to a Continued Status Differentiation Between Male and Female Librarians." In *Women and Library Management: Theories, Skills, and Values.* Edited by Darlene E. Weingand. Ann Arbor, Mich.: Pierian, 1982: 3-13.

Explores possible explanations for the studies that consistently find women

underrepresented in managerial positions. Factors such as leadership training, professional participation, and publishing are examined from the perspective of subtle social pressures on women. Suggests that adopting a male model (firm handshakes and gray suits) is not the answer.

1982-37C Dragon, Andrea. "Leadership: Myths, Theories, and Beliefs." In *Women in Library Management: Theories, Skills, and Values.* Edited by Darlene E. Weingand. Ann Arbor, Mich.: Pierian, 1982: 15-23.

General theories of leadership and leadership training are described and applied to library work.

1982-37D Sullivan, Peggy. "Politics, People, and Power: Women in Library Associations." In *Women and Library Management: Theories, Skills, and Values.* Edited by Darlene E. Weingand. Ann Arbor, Mich.: Pierian, 1982: 25-33.

Absorbing collection of facts and stories about women and their library association activity.

1982-37E Melin, Nancy Jean. "Publishing—How Does It Work?: The Journal Literature of Librarianship." In *Women and Management: Theories, Skills, and Values.* Edited by Darlene E. Weingand. Ann Arbor, Mich.: Pierian, 1982: 71-75.

Observing that "women have not been well represented in the journal literature of librarianship," essay offers several tips on getting published.

1982-37F Clarenbach, Kathryn F. "Women as Managers: Does It Make a Difference?" In *Women and Library Management: Theories, Skills, and Values.* Edited by Darlene M. Weingand. Ann Arbor, Mich.: Pierian, 1982: 101-108.

Suggests that women library directors can "make a difference" by balancing library collections, humanizing the workplace, and using women's groups to fight censorship threats.

1982-37G Weingand, Darlene E. "Women and Library Management: The Challenge Revisited." In *Women and Library Management: Theories, Skills, and Values.* Edited by Darlene E. Weingand. Ann Arbor, Mich.: Pierian, 1982: 109-110.

Concludes 1981 Madison, Wisconsin, conference on women and library management, noting that "the role of women in relation to the stresses and opportunities of library management is one of positive occasion for growth."

1982-38 Wilson, Pauline. *Stereotype and Status: Librarians in the United States.* Westport, Conn.: Greenwood, 1982.

Sex is *not* the focus of this study of occupational stereotype, but the predominance of women in the profession is mentioned in a number of chapters. For example, in a study of documents, the author notes that males engaged in a "count me out" manuever, which leaves the stereotype to apply only to women (p. 15). Of publications used in the aforementioned study, authors were 52

percent male—a high proportion considering their overall minority presence in librarianship (pp. 20-21). Other comments about gender are scattered throughout.

1982-39 *Your Assessment Center in Action: Third Year, July 1, 1981-June 30, 1983.* Seattle, Wash.: Career Development and Assessment Center for Librarians, 1982.

The fiscal 1982 annual report of the Career Development and Assessment Center for Librarians (CDACL) contains six sections, including a personal report by Peter Hiatt, third-year highlights, project overview, and future themes. Table (p. 25) shows that 82 women and seven men had participated. The center was first opened to men in the third year only. Future recommendations include creating a permanent program within the Pacific Northwest Library Association (PNLA) region, duplicating the program in other regions, and expanding assessment and career development to other feminized professions.

1982-40 Zipkowitz, Fay, and Bergman, Sherrie S. "Never Mind Who's Watching the Store, Who's Stocking the Pool?" In *Options for the 80s: Proceedings of the Second National Conference of the Association of College and Research Libraries.* Edited by Michael D. Kathman and Virgil F. Massman. Greenwich, Conn.: JAI Pr., 1982: 387-394.

Published version of [1981-40].

1982-41 "Conservative Journals Attack ALA on ERA." *American Libraries* 13 (January 1982): 15.

Reports the attack on libraries in the *Phyllis Schlafly Report*, which accuses librarians of biased acquisition policies in favor of the Equal Rights Amendment. Includes response of Judith Krug and the ALA Office for Intellectual Freedom.

1982-42 Ferriero, David S. "ARL Directors as Protégés and Mentors." *Journal of Academic Librarianship* 7 (January 1982): 358-365.

Survey results from seventy male and eleven female ARL directors are analyzed. Interesting comparisons are drawn between the behavior of men and women directors as protégés and as mentors. The current protégé gender ratio (men are mentoring a group of protégés who are 53 percent female, while the protégés of women are 76 percent female) shows that women are "doing more than their share" to provide opportunities to younger colleagues.

1982-43 Nyren, Karl. "News in Review, 1981." *Library Journal* 107 (January 5, 1982): 139-150.

Recounts pay equity struggles and successes in San Jose, California, and Ottawa, Ontario (p. 149). Describes the nature of the position of women in library management, using the findings of Irvine, Heim, and Kacina. Counts attendance at national conferences, and finds 50/50 representation by sex. Notes,

however, that at a Pittsburgh conference men outnumbered women panelists by four to one.

1982-44 "Semiannual Report on Developments at the Library of Congress, April 1, 1981, Through September 30, 1981." *Library of Congress Information Bulletin* 41 (January 8, 1982): 9-28.
Activities of the Women's Program Office are reported.

1982-45 "Avoid Librarianship, Ambitious Women Advised." *LJ/SLJ Hotline* 11 (January 25, 1982): 3.
Quote from Thelma Kandel's *What Women Earn.*

1982-46 Collier, H. R. "European Online Users." *Online Review* 6 (February 1982): 27-37.
Respondents to a questionnaire were asked to complete the profile of a typical online searcher in their organization. Responses led to some confusion: "56.1 percent were male, 40 percent were female, and 1.4 percent both."

1982-47 Heim, Kathleen M. "ILA-ERA Task Force." *Illinois Libraries* 64 (February 1982): 142-143.
Report of activities of the Illinois Library Association-Equal Rights Amendment (ILA-ERA) Task Force. The group stood vigil at the state capitol on Library Legislation Day, staffed a booth with Women Library Workers at the annual conference, and "plans to continue its work until the ERA is passed."

1982-48 "Little Future for Women in Library Careers." *Library Journal* 107 (February 1982): 388.
Reports that Thelma Kandel's *What Women Earn* warns that female-intensive professions such as librarianship should be avoided by career women seeking equitable salaries and career ladders that assure professional growth. Recommended fields include computer technology, secretarial work, and Wall Street careers.

1982-49 "Canada Sex Bias Complaint Dismissed on a Technicality." *Library Journal* 107 (February 1, 1982): 214.
Reports Canadian Human Rights Commission ruling that the fifty-two women at the National Research Council who received salary increases could not receive back pay, as did Treasury Board researchers. The ruling was passed on the premise that the two groups worked for different employers.

1982-50 Turner, Gurley. "Women's Caucus at SLA." *Library Journal* 107 (February 1, 1982): 204.
Letter of thanks in response to *Library Journal* coverage of SLA Women's Caucus activities [1981-105]. Corrects attendance figures—125 people were present at the Women's Caucus's first program, not seventy-five as reported.

1982-51 Darling, Lisa. A. H. "Young Women, Too." *Library Journal* 107 (February 15, 1982): 375.

Letter in response to E. M. Oboler's "From Books to Bytes" (*Library Journal*, October 1, 1981) chides author for use of the term *young bucks*. Writes that "there were, are, and will be women in libraries."

1982-52 Durrance, Joan C. "Continuing Education." *Journal of Education for Librarianship* 22 (Spring 1982): 303-306.

The Career Development and Assessment Center for Librarians (CDACL) is described in the light of library educators' responsibility for continuing education. Suggests that while the center's work toward stimulating career planning and development of management objectives may be measured immediately, major objectives, such as the readjustment of the percentages of women in library administration, will take longer to emerge.

1982-53 Heckel, John W. "Questions and Answers." *Law Library Journal* 75 (Spring 1982): 303-304.

In response to a question on the role of women in the American Association of Law Libraries (AALL), the author gives a brief sketch of key women and their contributions to AALL.

1982-54 Kilpela, Raymond. "Library School Faculty Doctorates." *Journal of Education for Librarianship* 22 (Spring 1982): 239-259.

Observes the general composition of library school faculties during the period between 1960 and 1978. While the number of Ph.D.s had grown and the number of women holding Ph.D.s had grown even more, percentages of women library school faculty dropped from 55.4 percent in 1960 to 48.6 percent in 1978. Report summarizes findings of all major library faculty surveys since 1960 and recommendations of the ALA Committee on the Status of Women in Librarianship and Committee on Accreditation Standards. Concludes that "the problem appears to lie in the need to recruit more women with an interest in teaching into the doctoral programs."

1982-55 Maack, Mary Niles. "Toward a History of Women in Librarianship: A Critical Analysis with Suggestions for Further Research." *Journal of Library History* 17 (Spring 1982): 164-185.

After reviewing current research on women in libraries, the author continues by suggesting "sources for a liberated history" such as Weibel and Heim's *Role of Women in Librarianship* and Andrea Hinding's *Women's History Resources*. Concludes with suggestions for further research into historical patterns, which would help explain the "low pay, feminization, and cultural priorities" that influenced the position of women in librarianship and the status of the profession as a whole.

1982-56 Perry-Holmes, Claudia. "Professional Part-time Jobs—An Encouraging Alternative for Women Librarians." *Current Studies in Librarianship* 6 (Spring/Fall 1982): 32-44.

Backed by numerous references and documented telephone conversations, the author makes a strong case for part-time work as a way to combine career and family, keep up with and demonstrate commitment to the profession, and use untapped resources among qualified personnel.

1982-57 "Attention Phyllis Schlafly." *American Libraries* 13 (March 1982): 207.

Notes computer search by Katharine Phenix and her midwinter report to the Committee on the Status of Women in Librarianship, finding that many public libraries did indeed offer titles listed in Phyllis Schlafly's newsletter as pro-life, pro-defense, pro-family, etc.

1982-58 Driscoll, Kathleen. "Top Pay Went to Women Too." *American Libraries* 13 (March 1982): 170.

Letter in response to article on salaries of University of Pittsburgh graduates (December 1981, p. 659) suggests that men's higher salaries cause women's lower salaries. Editor's note states that only five of the seventeen graduates of the University of Pittsburgh's bachelor's program were men.

1982-59 "Nominees 52 Percent Male." *American Libraries* 13 (March 1982): 207.

The Committee on the Status of Women in Librarianship reports that ALA councillor nominees are 52 percent male and 48 percent female. Also reported are COSWL publications and activities at midwinter.

1982-60 Roberts, Stephen. "Feminism in Perspective." *Information and Library Manager* 1 (March 1982): 124.

Looks for an empirical approach to feminism and library management. Feminism and sexism are only two of many variables that act on the library work world.

1982-61 "U. of Min. Pays $19,647 to Beginning Librarians." *American Libraries* 13 (March 1982): 162.

Summarizes 1981 ARL Salary Survey, which reported that men typically earn 5 percent more than women in comparable jobs.

1982-62 Fenton, Andrew. "Speling Equality." *Library Journal* 107 (March 1, 1982): 485.

Comment on cover photo of *Library Journal* (November 1, 1981) wonders if "female equality was in eny (sic) way compromised by the spelling on the signs."

1982-63 Herring, Mark Y. "Gendered Language." *Library Journal* 107 (March 1, 1982): 485.

Facetious use of nonsexist language in response to a letter (October 15, 1981) notes, "We in the library worldhood think more of the words than the thought behind themer or therer."

1982-64 Nyren, Karl. "ACRL in Minneapolis." *Library Journal* 107 (March 1982): 608-615.

Short summary of paper "ARL Academic Library Leaders of the 1980s: Men and Women of the Executive Suite" given by Betty Jo Irvine.

1982-65 Pritchard, Sarah. "Reports on the Midwinter Meeting of the American Library Association, Denver, Colo., January 23-28, 1982: SRRT Feminist Task Force." *Library of Congress Information Bulletin* 41 (March 5, 1982): 74.

Report summarizes plans made at Midwinter Meeting to stimulate feminist involvement in ALA and to increase communication among related women's groups. Also reports action taken by Feminist Task Force.

1982-66 "Women's Program Office Offers Specialized Day Care Directory." *Library of Congress Information Bulletin* 41 (March 7, 1982): insert.

Describes day-care directory compiled by the Women's Program Advisory Committee (WPAC) and reprints part of it.

1982-67 Chalfant, Patricia J. "Keeping Women Out." *Library Journal* 107 (March 15, 1982): 572.

Letter objects to sexist terminology by Charles O'Halloran (December 15, 1981), which disenfranchises women.

1982-68 Bundy, Mary Lee, and Slakem, Teresa. "Librarians and Intellectual Freedom: Are Opinions Changing?" *Wilson Library Bulletin* 56 (April 1982): 584-589.

Results of an opinion survey of 351 librarians (70 percent women) show no major differences in attitudes by sex. What differences were noted "suggest that as a group the men are slightly less liberal than the women" (p. 588).

1982-69 Mutari, Ellen; Rubin, Mary; Sacks, Karen; and Selden, Catherine R. "Equal Pay for Work of Comparable Value." *Special Libraries* 73 (April 1982): 108-117.

Provides comprehensive background on general comparable-worth action. Notes that "librarians, nurses, secretaries, and all other women who take pride in their work but receive little in return for it must ally together to solve this common problem collectively."

1982-70 Rytina, Nancy F. "Earnings of Men and Women: A Look at Specific Occupations." *Monthly Labor Review* 105 (April 1982): 25-31.

Presents 1981 annual average data on number of men and women working

full time in specific occupations and on their usual weekly earnings. Data on librarians appear in Table 1 (p. 26). Also includes librarians in Table 3 (p. 30), which lists occupations with the highest median weekly earnings for women employed full time in wage and salary work based on 1981 annual average.

1982-71 Zamora, Gloria, and Adamson, Martha C. "Authorship Characteristics in Special Libraries." *Special Libraries* 73 (April 1982): 100-107.

Compares authorship characteristics of five special library journals: *Special Libraries, Bulletin of the Medical Library Association, Journal of the American Society for Information Science, Law Library Journal,* and *Online.* Gender ratio of the profession associated with each journal, sex of editor, and percentages of women published are explored among other variables. Researchers found sex bias in favor of men.

1982-72 Cline, Gloria S. "College and Research Libraries: Its First Forty Years." *College & Research Libraries* 43 (May 1982): 209-231.

Study examines changes that have occurred in publication and citation patterns of *College & Research Libraries* from its inception in 1939 through 1979. Data were tabulated by sex for the principal author and revealed that principal authors were overwhelmingly male (78.85 percent), with females contributing only 21.12 percent of all articles. Data on sex of cited authors were also tabulated and revealed that males were cited 72.75 percent compared with 11.29 percent for females.

1982-73 "Men Outnumber Women Among Nominees." *American Libraries* 13 (May 1982): 328.

Reports findings of the ALA Committee on the Status of Women in Librarianship on gender ratios of the 1982 council nominees. Only 48 percent were women, although women outnumbered men three to one in the general membership. Other percentages are also reported.

1982-74 Plotnik, Art. "Of Women and Men . . . and ALA Elections." *American Libraries* 13 (May 1982): 285.

Editorial counts women (white and black) appointed to top-level library positions. Suggests that such appointment is less "extraordinary" than in the past. Further urges librarians to vote for "genderless spirit" in the upcoming ALA presidential race by Alice Ihrig, Norman Horrocks, and Brooke Sheldon.
Letters:
> Battin, Patricia. "Of Women and Men." *American Libraries* 13 (July/August 1982): 448. Abhors editorial implication that women may be hired on the basis of their sex and not their qualifications.
> Hogan, James. "Your Editorial, 'Of Women and Men.'" *American Libraries* 13 (July/ August 1982): 448. Believes that editorial "does nothing to assuage the battle of the sexes" and "fails to support, unequivocally, the premise that the best person

should win." Editor's note argues that there was nothing in the text implying that the woman hired was not the best person for the job.

1982-75 Shallow, Robert. "The Shallow End." *New Library World* 83 (May 1982): 67.

Comments on feminist notices submitted to *New Library World* and subsequently lost and unpublished.

1982-76 "San Diego Raises Librarian Salaries 18%." *LJ/SLJ Hotline* 11 (May 24, 1982): 5.

Reports pay increases of between 8 and 18 percent. Notes that most of the librarians and clerical staff benefiting from the raises are women, but emphasizes that the raises have nothing to do with the salary discrimination suit of city workers.

1982-77 "Special Librarians Attack Proposed New Federal Personnel Standards." *LJ/SLJ Hotline* 11 (May 31, 1982): 4.

SLA states, among other objections to the Office of Personnel Management (OPM) standards, that "since 75 percent of all librarians are women, the standard would have a discriminatory effect on the female federal library workforce."

1982-78 "Eleanor Holmes Norton Will Speak at OLPR/ALA Conference Program." *Tar Heel Libraries* 5 (May/June 1982): 6.

Describes panel discussion "Just What Does a Librarian Do?" on comparable pay and minimum qualifications offered by the Office for Library Personnel Resources (OLPR) at the ALA Annual Conference in Philadelphia. Speakers include Eleanor Holmes Norton, Suzanne Mahmoodi (Minnesota State Library), Ellen Cook (Federal Librarians Round Table), and Patt Curia (San Jose Public Library).

1982-79 "Women's Round Table." *Tar Heel Libraries* 5 (May/June 1982): 5.

Announces upcoming two-day workshop "Getting Our Fair Share: Personally and Professionally" sponsored by the North Carolina Library Association Round Table on the Status of Women in Librarianship. Workshop focuses on equal pay for equal work and other economic issues facing libraries.

1982-80 Patterson, Charles D. "Association Activities." *Journal of Education for Librarianship* 23 (Summer 1982): 57.

Report on AALS Board of Directors meeting notes that ALA Council has rescinded the action barring Chicago as a convention site.

1982-81 Barrett, Elinor. "Women in Libraries Committee: Celebrating Fifth Anniversary." *Missouri Library Association Newsletter* 13 (June 1982): 6.

Detailed history of the Missouri Women in Libraries Committee formed in 1977. Through the years, the group sponsored reports on women in manage-

ment, assertiveness training, and archival resources on Missouri women and paraprofessionals. They were also active in support of the Equal Rights Amendment. Readers are invited to a 1982 conference reception to celebrate the Committee's fifth anniversary.

1982-82 "Budget Deficit Preoccupies Executive Board Spring Meeting." *American Libraries* 13 (June 1982): 414-417, 419.

ERA Task Force reports $8,000 in grants to library associations in Illinois, Oklahoma, and Florida.

1982-83 Fretwell, Gordon. "A Special Report on Rank, Salary, and Other Data from the *1981 ARL Annual Salary Survey*." Prepared for the Committee on ARL Statistics, June 1982. Washington, D.C.: ARL, 1982.

Analysis of an optional questionnaire included with the 1981 salary survey on rank structure and distribution of rank among the professional staff. Table displaying "Average Salary and Years of Experience within Rank and Rank Structures" (p. 5) presents salaries by sex. In all cases but one, women earn lower average salaries—in many cases they have more cumulative experience. In the one case, women's average experience was almost double that of men, yet their salary advantage was less than $2,000.

1982-84 McEldowney, W. J. "Qualified Staff in New Zealand Libraries 1951-1980." *New Zealand Libraries* 43 (June 1982): 154-157.

Statistics include age and sex of staff by type of library and qualifications, as well as grades achieved in university libraries by age and sex.

1982-85 Ritchie, Sheila. "Women in Senior Library Management: A COPOL Seminar." *Information and Library Manager* 2 (June 1982): 19-20, 23.

Written account of the seminar "Women in Library Management" held May 12, 1982, at the City of London Polytechnic (COPOL). Participating women brainstormed to explain why women have low status in libraries, then broke into discussion groups. Summary notes that while, originally, individual women were considered the problem (are less ambitious, are socialized), final statements reflect a growing conviction that problems are more structural and general, and less individual and particular.

1982-86 Steer, Carol. "CLJ Authors Are Studied." *Canadian Library Journal* 39 (June 1982): 151-155.

Uses Olsgaard method to analyze the publishing patterns of Canadian librarians in one journal. Findings were consistent with the Olsgaard study—women published less than their male counterparts (48.1 percent), and only 34.8 percent of publishing academic librarians were women.

1982-87 Greear, Yvonne. "Job Satisfaction." *Library Journal* 107 (June 1, 1982): 1021.

Author expresses the sentiment that she likes being a librarian and that job

satisfaction may be more important than salary advantages.

1982-88 "Another Comparable Worth Raise for Library Staff." *LJ/SLJ Hotline* 11 (June 8, 1982): 1.

Director Carolyn Sutter reports that the city of Long Beach, California, awarded a "comparable worth pay increase of 5%."

1982-89 "Semiannual Report on Developments at the Library of Congress, October 1, 1981, Through March 31, 1982." *Library of Congress Information Bulletin* 41 (June 11, 1982): 160-180.

Includes coverage of Women's Program Office activity and results of the new affirmative action plans.

1982-90 "ALA Executive Board Eyes LSCA, Data Base, ERA." *Library Journal* 107 (June 15, 1982): 1161.

Reported among activities of the ALA Executive Board at the 1982 spring meeting is discussion of the possibility of lifting the conference boycott of states that had not ratified the ERA.

1982-91 "Career Change Opportunities Discussed at WPAC Seminar." *Library of Congress Information Bulletin* 41 (July 9, 1982): insert.

Panel discussion "Your Career! Self Motivated Changes," one of the Women's Program Advisory Committee's Career Development Series of Lunchtime Seminars, is noted.

1982-92 "Comparable Pay Comes to Long Beach." *American Libraries* 13 (July/August 1982): 472.

Thanks to Long Beach Public Library director Carolyn Sutter and the city manager, librarians received a comparable-worth pay increase.

1982-93 "ALA Council Votes to Rescind 'ERA Boycott.'" *MPLA Newsletter* 27 (August 1982): 10.

Reprints announcement published in *Cognotes Daily News* (July 12, 1982) that ALA Council voted to rescind the boycott on holding meetings in non-ERA-ratified states.

1982-94 *Degrees and Certificates Awarded by U.S. Library Education Programs 1979-81*. Chicago: American Library Assn., August 1982.

Data from AALS Library Education Statistical Report are supplemented by an OLPR questionnaire reporting number of graduates of U.S. library schools by sex and ethnicity. Highest percentage of female (82.2 percent) graduates is reached in this year, and a drop in the number of women receiving doctorates is noted (from 69.6 percent in 1979-1980 to 57.4 percent in 1980-1981).

1982-95 Wood, Charlotte, and Hamilton, Ruth. "Focus on Management." *Technicalities* 2 (August 1982): 10-11.

The codirectors of the Career Development and Assessment Center for Li-

brarians (CDACL) at the University of Washington present the center's genesis, activities, and observations. Designed to aid librarians, especially women, the program has trained fifty-two assessors during its three-year history. Emphasis is on management expertise at every level of librarianship.

1982-96 "New Members Sought for Women's Program Committee." *Library of Congress Information Bulletin* 41 (August 13, 1982): insert.

Describes the history and purpose of the WPAC. Box insert notes an opportunity for LC staff to learn more about the committee at an upcoming panel discussion during which Morrigene Holcomb will provide background information.

1982-97 "Reports on the 75th Annual Meeting of the American Association of Law Libraries, Detroit, Mich., June 13-17, 1982." *Library of Congress Information Bulletin* 41 (August 13, 1982): 236-238.

Section describes "Status of Men and Women in Law Librarianship," a panel discussion at the AALL annual meeting.

1982-98 "Reports on the Annual Conference of the American Library Association, Philadelphia, Pa., July 10-15, 1982." *Library of Congress Information Bulletin* 41 (August 27, 1982): 261-268.

Feminist Task Force activities are described by Sarah Pritchard (pp. 263-264), and Judy Kessinger recounts the program "Women and Power(lessness)" sponsored by the LAMA Women Administrators' Discussion Group.

1982-99 Biggs, Mary. "Librarians and the 'Woman Question': An Inquiry into Conservatism." *Journal of Library History* 17 (Fall 1982): 411-428.

Analyses of the nature of attitudes of women in libraries in the nineteenth century. Suggests that women librarians' early failure to assert themselves is explained through librarianship's relationship to teaching. "Impediments to feminism" are considered to be the attitudes that equate teaching with motherhood and actually discourage feminism by adhering to the virtues ascribed to true womanhood.

1982-100 Parks, Jim. "ALA Councilor's Report." *Mississippi Libraries* 46 (Fall 1982): 70-71.

"We may go home again," says ALA Councilor, reporting on Annual Meeting Council debate on the ERA. Notes that the association's concern for the status of women was reaffirmed.

1982-101 Reid, Marion T. "Professional Salaries in Louisiana Academic Libraries." *LLA Bulletin* 45 (Fall 1982): 82-83.

Questionnaires returned from twenty-eight academic and professional school libraries offer salary data for 192 female and eighty-three male Louisiana librarians. In general, in libraries with professional ranks, male average salaries are higher than female average salaries except at the instructor level; and in all job

categories, women have a higher average number of years of experience than men.

1982-102 Wagner, Ron. "1981/1982 Annual Reports: Liaisons." *Nebraska Library Association Quarterly* 13 (Fall 1982): 16-17.

ALA Councillor reports Council action to rescind boycott of ERA unratified states.

1982-103 "ALA Meets in Quaker City: A Conference Report." *Wilson Library Bulletin* 57 (September 1982): 23-33.

Under the heading "Equal Opportunity and Pay Equity at OLPR," the presentation by Eleanor Holmes Norton, former head of the Equal Opportunity Employment Commission, is described. Norton suggested that librarians reevaluate existing job criteria and concluded, "The library profession has a large stake in its own professionalism; but given all that this great profession has stood for, it also has a large stake in fairness, wage equity, and equality."

1982-104 "ALA III: Go for It!" *American Libraries* 13 (September 1982): 510-539.

Report of the 101st Annual ALA Conference includes discussion of the rejection of Membership Document 10 "Regarding the Location of Midwinter Meetings," which sought to defer returning to Chicago until after fall elections to pressure for ERA support before rescinding the boycott of non-ERA-ratified states. Kay Cassell's amendment to reaffirm ALA support of ERA and other women's rights issues passed with a vote of 186 to 176 (p. 512). Also reported is a panel discussion offered by the LAMA Women Administrators' Discussion Group and the Committee on the Status of Women in Librarianship on women in management (pp. 533-534).

1982-105 "Aspiring Women Learn How to Attain Organizational Power." *American Libraries* 13 (September 1982): 533-534.

Report given by the Library Administration and Management Association's Women Administrators' Discussion Group, together with the Committee on the Status of Women in Librarianship, at the 101st ALA Annual Conference concludes that the distribution of power in librarianship is still traditional, reflecting a political and/or economic double standard dating from Melvil Dewey's time.

1982-106 Gerhardt, Lillian N.; Cheatham, Bertha M.; and Pollack, Pamela D. "Responsiveness and Awareness: ALA's 101st Annual Conference." *School Library Journal* 29 (September 1982): 34-41.

Notes that ALA can return to Chicago, as the boycott of ERA-unratified-states has been rescinded. Also notes Council agreement to removal of sexist language in the bylaws (pp. 35-36).

1982-107 Hamilton, David K. "Citizen Participation in Suburbia: The Library Board." *Illinois Libraries* 64 (September 1982): 955-962.

Study of forty-two library boards in the Chicago area presents tables and analyses of library boards and their relationships to the library and to the community. Data are broken out by sex. Women were generally found to be more strongly supportive of library services than men.

1982-108 Jackson, Bryant H. "Higher Education General Information Survey, 1980-81." *Illinois Libraries* 64 (September 1982): 889-910.

No analyses accompany these data from the Higher Education General Information Survey-Library General Information Survey (HEGIS-LIBGIS) statistical data for Illinois academic libraries. Tables on pages 895 through 902 present full- and part-time staff and salaries by position and sex.

1982-109 Mech, Terrence. "The Small College Library Director of the Southwest." *Arkansas Libraries* 39 (September 1982): 25-29.

Who are the small college library directors of the Southwest, and how do they compare with Association of Research Libraries (ARL) directors? Data from questionnaires returned from fifty-three library directors show that Southwest library directors are composed of 39.6 percent women (as opposed to ARL's 15.3 percent); they are also slightly older than their male counterparts in both sets, move less often, and are more likely to have been hired internally.

1982-110 "OLOS, OFR, and ERA Ignite Two Membership Meetings." *American Libraries* 13 (September 1982): 511-512.

Synopsis of business transacted at ALA membership meetings held during the 101st ALA Annual Conference includes discussion of the Equal Rights Amendment.

1982-111 Ramer, Bob. "ALA 1982 Annual Conference Council Report." *Arkansas Libraries* 39 (September 1982): 39-40.

Notes end of ALA's boycott of non-ERA-ratified states.

1982-112 Ramer, James. "ALA Councilor's Report; 101st Annual Conference." *Alabama Librarian* 33 (September 1982): 6.

One sentence of interest reads: "ALA's boycott of non-ERA states as conference sites was lifted."

1982-113 Rochester, Maxine K. "Survey of Completers of First Professional Qualifications in Librarianship at Australian Library Schools in 1981." *Australian Academic and Research Libraries* 13 (September 1982): 144-150.

Personnel data for new entrants include sex, marital status, and age of the graduates. Data are compared with 1973 and 1974 surveys. Totals are forty-seven male and 277 female graduates.

1982-114 Berry, John; Havens, Shirley; Nyren, Karl; et al. "The Balancing Act: A Report on the 101st Annual Conference of the American Library Association,

with the Pennsylvania Library Association, in Philadelphia, July 10-15." *Library Journal* 107 (September 1, 1982): 1595-1610.

Reportage of conference activity includes description of Council and membership votes on ALA's stance on the Equal Rights Amendment; the SRRT Feminist Task Force's efforts to oppose Association of Federal Abortion legislation; and an OLPR session featuring former chair of the Equal Employment Opportunity Commission, Eleanor Holmes Norton.

1982-115 "Temple Librarians Drop Complaint to Get Ten-Month Year." *Library Journal* 107 (September 1, 1982): 1586.

Pay equity complaint filed with the Equal Employment Opportunity Commission in 1978 is reported dropped.

1982-116 "Reports on the Annual Conference of the American Library Association, Philadelphia, Pa., July 10-15, 1982." *Library of Congress Information Bulletin* 41 (September 17, 1982): 292-296.

Description of membership and Council meetings by Suzy Platt and Cynthia J. Johanson includes membership vote to reaffirm ALA support of ERA and to take no action about the relocation of midwinter meetings to Chicago until midwinter 1983 (passed 186 to 176) (p. 292), and Council attention to the ERA Task Force report (p. 293).

1982-117 Gagnon, Alain. "Les Femmes Bibliothécaires et les Postes Supérieurs." *Argus* 11 (September-October 1982): 99-103.

Author discusses representation of women in upper management in light of "fear of success" theory.

1982-118 Hanna, Alfreda. "ALA Councilor's Corner." *Oklahoma Librarian* 32 (September/October 1982): [7].

Notes Council vote to rescind the ALA boycott of ERA-unratified states; membership meeting attempts to hold off a boycott decision until post-election November; and association saves by returning to Chicago.

1982-119 Beller, Andrea H. *Trends in Occupational Segregation by Sex: 1960-1990*. Working Papers in Population Studies, no. 8203. Urbana, Ill.: University of Illinois at Urbana-Champaign, School of Social Sciences, October 1982.

Study of occupational segregation trends notes in Table B-3 (pp. 51, 53) "Actual and Projected Proportion Female for Detailed Occupations" and Table B-5 (p. 57) "Actual and Projected Proportion Female for College Majors, 1969-1989" no projected differences in the sexual composition of librarianship.

1982-120 Hook, Robert D. "ALA Report." *Idaho Librarian* (October 1982): 176-178.

ALA Chapter Councilor reports that the motion to rescind the boycott of states that have not ratified the ERA was one of the first items passed by the ALA Council at the 1982 Annual Conference in Philadelphia.

1982-121 "Feminist Librarians." *Library Journal* 107 (October 1, 1982): 1832.

"Checklist" advertises *SHARE: A Directory of Feminist Library Workers*, edited by Katharine Phenix and published by Women Library Workers at the University of Illinois Graduate School of Library and Information Science.

1982-122 Learmont, Carol L., and Van Houten, Stephen. "Placements and Salaries, 1981: Still Holding." *Library Journal* 107 (October 1, 1982): 1821-1877.

Authors note no dramatic changes in current-year placements and salaries of library school students. Women's average salaries still lag behind men's, $15,478 to $16,516.

1982-123 "Ninth Library School Survey: Changes at Helm, Gains for Women." *Library Journal* 107 (October 1, 1982): 1803-1804.

Summary of Russell Bidlack report [1982-01A] of faculty trends and salaries for sixty-nine ALA-accredited library education programs. Women have gained 11 percent more representation at the assistant professor level (43.2 percent total), but have lost at the associate professor level.

1982-124 "Women in Libraries: Footnote to History from Harvard." *LJ/SLJ Hotline* 11 (October 4, 1982): 3.

Radcliffe College exhibit notes back pay won by library cleaning women in 1929.

1982-125 Woodworth, Eileen B. "Sexist Statements." *Library Journal* 107 (October 15, 1982): 1915.

Letter objects to sexist statements made by Dean Burgess (May 15, 1982). Criticizes *Library Journal* editors for allowing "nobody's little sister" in the title and Burgess's comment that "the majority of legislators are middle aged men, and attractive women librarians are an asset we have and would be foolish to waste."

1982-126 Hutter, Gregory W. "I Say . . . " *Journal of Information Science* 5 (November 1982): 43-44.

Appears to be suggesting that since women are "magnificently absent from the military complex, probably discovered fire, and performed the hardest work in British coal mines, . . . the feminist challenge is to get more involved in library high technology and bring analog back to counteract the digital."

1982-127 Marchant, Maurice P., and Smith, Nathan M. "How to Win Election to ALA Council." *American Libraries* 13 (November 1982): 643-644.

Study finds both men and women equally likely to get elected to ALA Council.

1982-128 "Stone Battles Latest Threat to Librarian Status, Pay Equity." *American Libraries* 13 (November 1982): 613-614.

Reports ALA past-President Elizabeth Stone's testimony at a congressional subcommittee panel and pay equity hearings.

1982-129 Jones, David J. "A Sampling of Librarians." *Incite* 3 (November 5, 1982): 3.

Summarizes survey results of 1980 ALA survey *The Racial, Ethnic, and Sexual Composition of Library Staff in Academic and Public Libraries* [1981-02].

1982-130 "Affirmative Action at the Library of Congress: A Historical Overview." *Library of Congress Information Bulletin* 41 (November 19, 1982): 383-388.

This second part of a history of affirmative action at the Library of Congress describes efforts of the Women's Program since its inception in 1976. Three tables depict (1) women in management at the Library of Congress; (2) protected classes as a percentage of professional librarians on staff (by sex); and (3) work force composition by sex and minority status, nationwide, in D.C., Standard Metropolitan Statistical Area (SMSA), and at the Library of Congress, 1980 (pp. 387-388). First table is corrected and updated in February 1983 [1983-38].

1982-131 "ALA Charges OPM Federal Librarian Standards Revision Unfair and Sexist." *LJ/SLJ Hotline* 11 (November 22, 1982): 4.

Reports ALA appeal for a thorough, full-scale review of the U.S. Office of Personnel Management policy statement on federal librarians. ALA charges that the proposed "revised standards" are sexist, treating the female-dominated profession more severely than comparable male professions in an effort to downgrade the status of professional librarians—a "deliberate discrimination against women."

1982-132 "New Women's Committee Formed." *Library of Congress Information Bulletin* 41 (November 26, 1982): insert.

Photo and names of the members of the Women's Program Advisory Committee.

1982-133 "Minutes of Board Meetings, November 12-13, Seattle, Washington." *PNLA Quarterly* 46 (Winter 1982): 50-55.

The Board of Directors of the Pacific Northwest Library Association are reported discussing the Career Development and Assessment Center for Librarians.

1982-134 Cassell, Kay Ann. "ALA and the ERA: Looking Back on the Association's Political and Fiscal Involvement." *American Libraries* 13 (December 1982): 690-696.

History of ALA-ERA and state association activity from 1977 to the present.

Includes photos of events during the five-year period. Notes that librarians must continue to monitor government actions that affect women's issues.

1982-135 Gerhardt, Lillian N.; Cheatham, Bertha M.; and Pollack, Pamela D. "82—A New Emphasis: AASL's Second National Conference." *School Library Journal* 29 (December 1982): 19-23.

Report of Gloria Steinem's speech "The Way We Were—and Will Be" to American Association of School Librarians (AASL) conferees. Steinem said that "librarians are at the forefront of a changing workforce," and she urged them to continue to achieve. "Don't believe in the myth that success will make you sick."

1982-136 Heim, Kathleen M., and Phenix, Katharine. "A Comparison of Children and Adult Services Librarians' Salaries in LACONI Member Libraries." *Illinois Libraries* 64 (December 1982): 1160-1167.

On the premise that low status is conferred to children's librarians because of the status of children in society and the predominantly female ranks of those who serve them, salary and experience data were gleaned from the Library Administration's Conference of Northern Illinois (LACONI) and compared with adult services librarians. While lower salaries for children's librarians could be documented, other variables (such as experience) served to lessen the likelihood of simple discrimination.

1982-137 "Library Faculty Salary Survey 1982-83." Oregon State System of Higher Education, Interinstitutional Library Council, December 1982.

Survey of faculty members at eight state colleges and universities in Oregon presents data on librarians employed as of September 1, 1982. Results are compared with ARL data and ALA salary data. Some observations: Only one female library faculty member had attained the rank of professor, compared with nineteen males; the male/female ratio (21:23) was closer at the associate professor level than at any other rank; over a four-year period, 36.6 percent of the female assistant professors were dropped as compared with 20 percent of the male assistant professors; however, the drop over all ranks was almost identical for both sexes; the highest paid female received $13,856 less than the highest paid male; and on the average, female faculty did not yet earn as much as did males in 1978-1979. Many other variables presented are broken out by sex.

1982-138 "A New Emphasis: AASL Meets in Houston." *Wilson Library Bulletin* 57 (December 1982): 278-280.

The second national conference of the American Association of School Librarians hosts Gloria Steinem as featured speaker at an "organizing session" on feminist issues. She notes that AASL is an important group because they are predominantly women and because libraries and librarians are a target for backlash against changes in education, the family, and books.

1982-139A Nelson, Milo. "Woman's Place Is in the Home." *Wilson Library Bulletin* 57 (December 1982): 276.

No mention of libraries intrudes in this balanced history of the Equal Rights Amendment, which introduces a special issue devoted to the concerns of women in libraries.

1982-139B Rivers, Caryl. "Justice for All: The Second Equal Rights Amendment." *Wilson Library Bulletin* 57 (December 1982): 289-291.

Proclaims that the Equal Rights Amendment is now in the process of resurrection and that women's fear of change may indeed be ERA's most powerful roadblock. Concludes that women need reassurance that one doesn't need to be against men in order to be for women and that it is not selfish or unfeminine to support the interests of females.

1982-139C Cassell, Kay Ann. "Librarians, Politics, and the ERA." *Wilson Library Bulletin* 57 (December 1982): 292-294.

Recounts key actions taken by ALA in support of the Equal Rights Amendment, as well as librarian-headed campaigns in Missouri, Florida, North Carolina, and Illinois. Concludes that ERA action has generated a new breed of library activists.

1982-139D Parikh, Neel, and Broidy, Ellen. "Women's Issues: The Library Response." *Wilson Library Bulletin* 57 (December 1982): 295-299.

Reports on services to women library users and access to information about women in libraries from both a public and an academic library perspective. Women who use libraries and women who work in libraries are called upon to combat such problems as budget, collection development policies, and service orientation in relation to women's materials and women users.

1982-139E Josephine, Helen. "All Things Being Equal: Pay Equity for Library Workers." *Wilson Library Bulletin* 57 (December 1982): 300-303.

Comparable-worth struggles by librarians and federal responses are described.

1982-139F Williamson, Jane. "The Struggle Against Sex Discrimination." *Wilson Library Bulletin* 57 (December 1982): 304-307.

Describes the major weapons against sex discrimination; namely, the Equal Pay Act of 1963, which guarantees equal pay for equal work, and Title VII of the Civil Rights Act of 1964, which guards against sexual harassment and pregnancy discrimination. Also explains affirmative action as outlined in Executive Order 11246 and enumerates changes proposed by the Reagan administration.

1982-139G Heim, Kathleen M. "Fighting for Social Change: Library Women Enter the Eighties." *Wilson Library Bulletin* 57 (December 1982): 308-312.

Highlights advances made by women in libraries through information gathering, association organizing, and coalition building. Survey results are summa-

rized, along with discussion of the growth of women-oriented groups involved in professional associations and description of alliances made with nonlibrary organizations. Poetically stated, "The seeds of determination sown in the seventies will result in a harvest of informed and politically astute women ready to change librarianship" (p. 311).

Letters:

Johanson, Cynthia. "Timely Issue." *Wilson Library Bulletin* 57 (February 1983): 456. Expresses appreciation for December issue of *Wilson Library Bulletin*, which was dedicated to the concerns of women in librarianship. Notes that it "reemphasizes women's issues beyond the Equal Rights Amendment era."

Lawless, Dolores. "A Pie in the Face." *Wilson Library Bulletin* 57 (March 1983): 550. Accuses editorial of being "unworthy of an editor of a library journal" and "emotional." Author finds editorial remarks about Phyllis Schlafly especially offensive. Calls the ERA a "bad piece of legislation" analogous to Pandora's Box.

Searing, Susan. "Spirits Are Buoyed." *Wilson Library Bulletin* 57 (April 1983): 630. Warm thanks are expressed for the *Wilson Library Bulletin* December issue. Notes that it is a useful resource for library students interested in women in librarianship.

1982-140 Plotnik, Art. "School Miracle Specialists Fuel Up in Spaceville." *American Libraries* 13 (December 1982): 684-686, 688.

Notes speech given by Gloria Steinem (p. 686) in which she praises the women who make up most of the school library field.

1982-141 Nzotta, Briggs C., and Harvard-Williams, Peter. "The Education, Training, and Qualification of Librarians in Nigeria." *Libri* 32 (December 1982): 316-326.

Table 1 (p. 318) displays qualifications of 267 respondents to a questionnaire sent to Nigerian librarians. Although there were fewer women in the sample (eighty-eight women to 179 men), the women had proportionally higher qualifications than the men.

1982-142 "Women's Division." *The Specialist* 5 (December 1982): [5].

Short announcement includes scope note for a new provisional division: "The Division of Women's Issues in the Profession's purpose is to provide a forum for discussion, analysis, and action on the social, economic, and professional concerns of women in special libraries."

1982-143 "Semiannual Report on Developments at the Library of Congress, April 1, 1982, Through September 30, 1982." *Library of Congress Information Bulletin* 41 (December 20, 1982): 412-428.

Describes Women's Program Office project to automate Library of Congress Personnel Data, the panel "Your Career! Self-Motivated Changes," and screenings of a film on sexual harassment.

1983-01 Addis, Patricia K. *Through a Woman's I: An Annotated Bibliography of American Women's Autobiographical Writings, 1946-1976.* Metuchen, N.J.: Scarecrow, 1983.

Annotated bibliography of American women's autobiographical writings, 1946-1976, includes autobiographies of librarians Caroline M. Lord, Caroline Maria Hewins, and Sally Belfrage.

1983-02 Bellassai, Marcia C. *Survey of Federal Libraries, FY78.* Washington, D.C.: Govt. Print. Off., 1983. (ED1.115:Su7) (4858-9 ASI 1983)

Covers collections, services, expenditures, and staff of federal libraries in the United States and foreign countries for the fiscal year 1978. Appendix B contains detailed tables showing data for individual libraries broken down by percent of all staff by sex.

1983-03A Bidlack, Russell E. "Faculty." In *Library and Information Science Education Statistical Report 1983.* State College, Pa.: Assn. for Library and Information Science Education, 1983.

Tenth report in Faculty Report series includes information on percentage of full-time faculty members who are women (Table I-3); changes in male-female full-time faculty ratio (Table I-4); rank and sex of forty-four new faculty (Table I-11); beginning salaries, broken down by sex, for assistant professors (Table I-12); and comparison of average faculty salaries for males and females in sixty-seven Association for Library and Information Science Education (ALISE) member schools on January 1, 1983 (Table I-15). Also shows male and female full-time faculty by initial year of appointment (Table I-19); compares male and female faculty promotions (Tables I-20 and I-21); breaks down, by sex, earned doctorates held by faculty members (Tables I-22 and I-22a); and gives information on tenure status by rank and sex (Table I-26a).

1983-03B Reagan, Agnes L. "Students." In *Library and Information Science Education Statistical Report 1983.* State College, Pa.: Assn. for Library and Information Science Education, 1983: S-1–S-69.

Includes information on enrollment by program and sex and on degrees and certificates awarded by sex and ethnic background based on fall 1982 term. Profile of the student body by number of students by sex and ethnic origin and by number of students by age and sex. Financial data show scholarships and assistantships awarded to students, broken down by amount, sex, and program level.

1983-04 Bryan, Alice I. "Alice I. Bryan." In *Models of Achievement.* Edited by Agnes N. O'Connell and Nancy Felipe Russo. New York: Columbia University, 1983: 68-86.

Bryan's memoirs describe her part in the "Public Library Inquiry" and her work in establishing the doctoral program at Columbia University. Her studies have focused on the personality of the librarian. Bryan is a self-described feminist, and she notes that she was the first woman to receive a doctorate from Columbia.

1983-05 Coe, Mary Jordan. "Personnel and Employment: Compensation." In *ALA Yearbook 1983*. Edited by Robert Wedgeworth. Chicago: American Library Assn., 1983: 205-206.

Notes that 1981 beginning salaries for graduates of ALA-accredited library education programs were $15,478 for women and $16,516 for men. Information on continuing importance of pay parity is also provided.

1983-06 Daval, Nicola. "Association of Research Libraries." In *ALA Yearbook 1983*. Edited by Robert Wedgeworth. Chicago: American Library Assn., 1983: 39-43.

Report includes the following information for fiscal year 1983, broken out by sex: number and average salaries of ARL university librarians, and number and average salaries of ARL minority librarians.

1983-07 Fu, Tina C. *Directory of Library and Information Profession Women's Groups*. 3d ed. Chicago: American Library Assn., 1983.

Describes library and information organizations concerned with the status of women in libraries and other feminist issues.

1983-08 Grant, W. Vance, and Snyder, Thomas D. *Digest of Education Statistics 1983-84*. Washington, D.C.: Govt. Print. Off., 1983. (ED1.113: 983-84)

Provides information on bachelor's, master's, and doctoral degrees conferred in 1980-1981, by sex of student and field of study (Table 100); data on bachelor's degrees conferred in 1980-1981 by U.S. institutions of higher education, by racial and/or ethnic group, major field of study, and sex of student (Table 101); data on master's degrees conferred in 1980-1981 by U.S. institutions of higher education, by racial and/or ethnic group, major field of study, and sex of student (Table 102); and data on doctor's degrees conferred in 1980-1981 by U.S. institutions of higher education, by racial and/or ethnic group, major field of study, and sex of student (Table 103). Data on associate degrees conferred in 1980-1981 are broken out by sex and include degree of library associate (Table 117).

1983-09A Harvey, John H., and Dickinson, Elizabeth M., eds. *Librarians' Affirmative Action Handbook*. Metuchen, N.J.: Scarecrow, 1983.

The case for affirmative action in libraries is made. Lengthy introduction provides background on and definitions of the concept of equal employment opportunity and the increased interest in affirmative action in this decade.

1983-09B Dickinson, Elizabeth M. "Affirmative Action in Public Libraries and State Library Agencies." In *Librarians' Affirmative Action Handbook*. Edited by John H. Harvey and Elizabeth M. Dickinson. Metuchen, N.J.: Scarecrow, 1983: 94-119.

Table 1 (pp. 98-99) shows racial, ethnic, and sexual composition of full- and part-time public librarians, beginning librarians, branch and department heads,

and directors as of April 1980. Other tables show mean salaries by sex and race, and median salaries for male and female directors in the United States from 1971 to 1981.

1983-09C Galloway, Sue. "Discrimination and Affirmative Action: Concerns for Women Librarians and Library Workers." In *Librarians' Affirmative Action Handbook.* Edited by John H. Harvey and Elizabeth M. Dickinson. Metuchen, N.J.: Scarecrow, 1983: 154-177.

Chapter discusses occupational segregation in general and within the profession, and proposes a positive plan to implement affirmative action for women in libraries.

1983-10 Heim, Kathleen M., and Estabrook, Leigh S. *Career Profiles and Sex Discrimination in the Library Profession.* Chicago: American Library Assn., 1983.

Commissioned by the ALA Committee on the Status of Women in Librarianship and funded by the Bailey K. Howard-World Book Encyclopedia-ALA Goal Award, this study presents data that show relationships among sex, status, and salary in librarianship. A range of personal, demographic, and career patterns are compared and cross-tabulated in this pioneering study of a sample of the members of the American Library Association. Authors intended to "provide data for evaluating the status of women in librarianship" and find that their data support and expand those of other studies that have identified significant differences between the treatment of men and women in the library profession. An extensive bibliography is appended.

Reviews:

"ALA Report Sees Male-Female Salary Discrepancy, Discrimination Against Women as Library Administrators." *Media Report to Women* 12 (September-October 1984): 6.

Black, Sophie K. *Booklist* 80 (October 15, 1983): 326.

Broidy, Ellen. "Recent Publications." *College & Research Libraries* 45 (November 1984): 518-519.

"Career Development Issues: Model Study." *Project of the Status of Education of Women* 13 (Fall 1983): 10.

De Muzio, Jean. "Book Reviews." *Library and Information Science Research* 6 (July-September 1984): 342-344.

Funnell, Catherine. "Book Reviews." *Canadian Library Journal* 41 (June 1984): 159-160. Review is also summarized in *Journal of Academic Librarianship* 10 (September 1984): 250.

Gasaway, Laura N. "Reviews." *Special Libraries* 75 (January 1984): 77-78.

Loeb, Catherine R. In *ARBA*, vol. 15. Edited by Bohdan S. Wynar. Littleton, Colo.: Libraries Unlimited, 1984: 143.

National Women's Studies Association Newsletter 1 (Fall 1983): 37.

Phenix, Katharine. "Women in Librarianship: Research." *WLW Journal* 8 (July-September 1983): 26.

"Received." *College & Research Libraries News* 44 (October 1983): 353.

"Sex Discrimination." *New Library World* 84 (December 1983): 206.

Stevens, Norman. "Our Profession." *Wilson Library Bulletin* (September 1983): 62.

1983-11A Heim, Kathleen. "Introduction." In *The Status of Women in Librarianship: Historical, Sociological, and Economic Issues*. Edited by Kathleen Heim. New York: Neal-Schuman, 1983: 1-6.

The editor presents the volume by noting that this is the first time a substantial body of scholarly research on women in librarianship has been assembled in one place.

1983-11B Hildenbrand, Suzanne. "Revision versus Reality: Women in the History of the Public Library Movement 1876-1920." In *The Status of Women in Librarianship: Historical, Sociological, and Economic Issues*. Edited by Kathleen M. Heim. New York: Neal-Schuman, 1983: 7-27.

What was the role of the public library in American history, or, even more to the point, what was women's role in the public library? *Apostles of Culture: The Public Librarian and American Society, 1876-1920* [1979-11] by Dee Garrison is viewed as a "revisionist" version of social history in this essay. It is contended here that the tendency to cite the high percentage of women in librarianship as the reason for the low status of the profession is to "blame the victim" and apply double standards to the historical contributions of Melvil Dewey and others. Pay equity and career paths with opportunity and greater autonomy are suggested goals for the future.

1983-11C Brand, Barbara Elizabeth. "Sex-Typing in Education for Librarianship: 1870-1920." In *The Status of Women in Librarianship: Historical, Sociological, and Economic Issues*. Edited by Kathleen M. Heim. New York: Neal-Schuman, 1983: 29-49.

In order to view more clearly women's position within librarianship, the author identifies patterns in recruitment into the profession. In all cases, the majority of library school students, from Dewey's school at Columbia and later Albany to Katharine Sharp's Armour Institute and later the University of Illinois, were women, even though both sexes were welcomed. It appears, however, that library schools were turning out women equipped to run small-to-medium-size libraries, while men without library training were appointed to top positions in academic or research libraries.

1983-11D O'Brien, Nancy Patricia. "Recruitment of Men into Librarianship Following World War II." In *The Status of Women in Librarianship: Historical, Sociological, and Economic Issues*. Edited by Kathleen M. Heim. New York: Neal-Schuman, 1983: 51-66.

Broken down by decade, ranging from pre-1940 to 1971-1980, arguments for and against the large-scale recruiting of men into the profession are recounted. A

case is made for preferential appointments of men to top library positions after the war. A little arithmetic indicates that as these men retire from the field in the same numbers in which they entered it, women may, if judged on the basis of competency not sex, have an opportunity to occupy leadership roles.

1983-11E Reeling, Patricia. "Undergraduate Women as Potential Recruits to the Library Profession." In *The Status of Women in Librarianship: Historical, Sociological, and Economic Issues*. Edited by Kathleen M. Heim. New York: Neal-Schuman, 1983: 67-98.

A study involving 658 full-time students attending Edgecliff College in Cincinnati, Ohio, in 1965-1966 identified student attitudes toward library science as a possible graduate major. Three experimental recruitment activities were tested on the students. Possible recruits (n=73) were tested to develop a personality profile. Author concludes that the best way to recruit top candidates for the profession is to improve the image of the librarian.

1983-11F Sukiennik, Adelaide Weir. "Assertiveness Training for Library School Students." In *The Status of Women in Librarianship: Historical, Sociological, and Economic Issues*. Edited by Kathleen M. Heim. New York: Neal-Schuman, 1983: 99-138.

Survey of studies of "personality profiles," the image of the "semiprofessions," and the preponderance of women in librarianship leads this author to conclude that curricular and extracurricular programs could be developed to assist women by (1) identifying attitudes and behaviors that are a result of sex-role socialization, and (2) identifying inappropriate attitudes exhibited toward women and learning productive ways to deal with the attitudes. A study using University of Pittsburgh Graduate School of Library and Information Sciences students enrolled in a required course indicates that such a program would be beneficial.

1983-11G Grotzinger, Laurel A. "Biographical Research on Women Librarians: Its Paucity, Perils, and Pleasures." In *The Status of Women in Librarianship: Historical, Sociological, and Economic Issues*. Edited by Kathleen M. Heim. New York: Neal-Schuman, 1983: 139-190.

The "paucity" of biographies of women librarians is demonstrated by looking at the major biographical sources for librarians as well as other common reference tools, both current and historical. "Perils" include subjective "tributes," theses and dissertations without adequate methodology, and collective biographical works that use inadequate criteria for selection. The "pleasures" section includes short paragraphs describing fourteen notable women librarians, with information from other biographical sources.

1983-11H Rhodes, Lelia Gaston. "Profiles of the Careers of Selected Black Librarians." In *The Status of Women in Librarianship: Historical, Sociological,*

and Economic Issues. Edited by Kathleen M. Heim. New York: Neal-Schuman, 1983: 191-205.

The socioeconomic backgrounds of fifteen black women librarians are studied using techniques supplied by the field of oral history. The author concludes with some advice given by these successful librarians and several recommendations for further study.

1983-11I Fennell, Janice C. "The Woman Academic Library Administrator: A Career Profile." In *The Status of Women in Librarianship: Historical, Sociological, and Economic Issues.* Edited by Kathleen M. Heim. New York: Neal-Schuman, 1983: 207-241.

Reports a study of women who were directors of the largest academic libraries in the United States at the time. Findings relate to personal background, education and training, experiential and professional background, role models, etc. The "career profile" at the end identifies traits and career moves considered likely to lead to a directorship for women.

1983-11J Martin, Jean K. "Salary and Position Levels of Females and Males in Academic Libraries." In *The Status of Women in Librarianship: Historical, Sociological, and Economic Issues.* Edited by Kathleen M. Heim. New York: Neal-Schuman, 1983: 243-285.

This study seeks to ascertain some of the variables that may relate to the disproportionate representation of women in management and their lower salary levels. Previous studies on work experience, education, age, marital status and children, mobility, work continuity, sex-role attitudes, professional development, career commitment, and personal motivations are identified. The actual study was restricted to a sample of librarians in 105 ARL libraries. Findings of this study show no evidence that females and males are treated differently in promotion and salary issues, but some personal variables, such as children, are a handicap to women's careers.

1983-11K Irvine, Betty Jo. "Women in Academic-Library, Higher-Education, and Corporate Management: A Research Review." In *The Status of Women in Librarianship: Historical, Sociological, and Economic Issues.* Edited by Kathleen M. Heim. New York: Neal-Schuman, 1983: 287-320.

Identifies major studies in the three institutional structures in order to delineate factors that commonly affect women's administrative career aspirations. Similarities among the three groups are identified, and role models and mentors are called for.

1983-11L Taylor, Marion R. "Mobility and Professional Involvement in Librarianship: A Study of the Class of '55." In *The Status of Women in Librarianship: Historical, Sociological, and Economic Issues.* Edited by Kathleen M. Heim. New York: Neal-Schuman, 1983: 321-344.

Individuals drawn from *Who's Who in Library Service* (1966) make up a

study group chosen to identify patterns of mobility—career, geographic, functional, and vertical. These mobility characteristics are observed in combination with career pattern, extra job characteristics, and professional involvement. The implications of the findings include the likelihood that men get preferential treatment in spite of immobility and that women are accepting a low rate of pay in spite of experience and longevity. The researcher did find, however, a strong connection between advanced degrees held (primarily by men) and success, and between low salary and immobility of women.

1983-11M Robinson, Judith Schiek. "Geographic Mobility and Career Advancement of Male and Female Librarians." In *The Status of Women in Librarianship: Historical, Sociological, and Economic Issues.* Edited by Kathleen M. Heim. New York: Neal-Schuman, 1983: 345-391.

Responses of academic librarians in the South to a questionnaire are compiled to identify demographic, mobility, and career progression data. Author concludes that "the depressed status of women in librarianship *cannot* be attributed to differences in the frequency of their job moves compared to men." In fact, a man who moved for any reason could expect to move upward, which a woman could not.

1983-11N Futas, Elizabeth. "An Analysis of the Study 'Career Paths of Male and Female Librarians in Canada.'" In *The Status of Women in Librarianship: Historical, Sociological, and Economic Issues.* Edited by Kathleen M. Heim. New York: Neal-Schuman, 1983: 393-423.

Critical analysis of the Canadian study [1977-35] identifies problems with the research methodology and the dissemination of the results. Few findings were statistically significant. In spite of these problems, it is suggested that the model be used again for research, perhaps in the United States, where librarians form a more homogeneous group.

1983-11O Dickson, Katherine Murphy. "The Reentry Professional Librarian." In *The Status of Women in Librarianship: Historical, Sociological, and Economic Issues.* Edited by Kathleen M. Heim. New York: Neal-Schuman, 1983: 425-435.

Describes the phenomenon and the problems of the reentry librarian. Author suggests that women have to choose between children and a career, and calls for more research on the subject.

Reviews:

Biggs, Mary. *Library Quarterly* 54 (April 1984): 192-193.

Black, Sophie K. *Booklist* 80 (October 15, 1983): 327.

Bunch, Antonia J. *Library Review* 33 (Spring 1984): 45-46.

Chamberlin, Leslie. *Public Libraries* 23 (Winter 1984): 143.

Du Mont, Rosemary Ruhig. *Journal of Library History, Philosophy, and Comparative Librarianship* 20 (Fall 1985): 332-334.

Galloway, Sue. "Marion's Slow Ascent." *American Libraries* 14 (April 1983): 188.

Josephine, Helen. *Journal of Academic Librarianship* 9 (September 1983): 231-232.

Nerboso, Donna. *Special Libraries* 74 (October 1983): 393-394.

Searing, Sue. *RQ* 23 (Fall 1983): 119.

Shuter, Janet. "How Should Women Measure Success?" *Library Association Record* 85 (October 1983): 384-385.

Stevens, Norman D. *Wilson Library Bulletin* 57 (June 1983): 878-879.

Stineman, Esther F. In *ARBA*, vol. 15. Edited by Bohdan S. Wynar. Littleton, Colo.: Libraries Unlimited, 1984: 142.

Williams, Claire Louise. *Riviera Library Review* 1 (Winter 1984): 142.

1983-12 Heim, Kathleen M., and Kacena, Carolyn. "Sex, Salaries, and Library Support, 1981." In *Bowker Annual*. 28th ed. New York: Bowker, 1983: 294-308.

Adaptation of [1981-115].

1983-13 Hildenbrand, Suzanne. "Women in Librarianship, Status of." In *ALA Yearbook 1983*. Edited by Robert Wedgeworth. Chicago: American Library Assn., 1983: 277-279.

Notes that although there is a continuing high level of concern with the status of women in the profession and in society, statistical coverage of major issues is disappointing. Beginning female median salary for 1981 ALA-accredited graduates is listed as $15,000, with a male equivalent of $15,500. Also includes information on career studies, authors, writers and speakers, career development, and salaries.

1983-14 Jankowsla-Janiak, Anna. "Losy Absolwentow Instytutu Bibliotekoznawtwa Universytetu Wroclawskiego." *Przeglad Biblioteczny* 2(3): 2880293 (1983).

Results of a survey on the employment of three hundred graduates of the Institute of Librarianship, Wroclaw University, reveal that of the 94 percent women graduates, only 10 percent were described as "qualified librarians."

1983-15 Jones, Dianne D. "Mollie Husten Lee: A Black Pioneer." Master's paper, University of North Carolina, Chapel Hill, 1983.

Sheds light on the position of the woman and the black librarian in America.

1983-16 Kieffer, Suzanne. *Women in Indiana Libraries Network Directory 1983*. Evansville, Ind.: Indiana Library Assn., Division on Women in Libraries, 1983.

First page identifies the purpose of the directory as being "to facilitate communications among women in libraries in Indiana." More than one hundred women are listed, along with their workplace and home address, job title, and interests.

1983-17 Kristy, Karen K. *Women in Librarianship: A Cross-National Problem Study.* Bethesda, Md.: ERIC Document Reproduction Service, 1983. (ED 238 453)

Author reviews the literature and data on the status of women librarians in three groups of countries: democratic, Soviet Bloc, and Third World. Concludes that in all areas, with the exception of Nigeria, librarianship is a female-intensive profession. Men dominate management positions, however, and earn higher salaries.

1983-18 Learmont, Carol L., and Van Houten, Stephen. "Placements and Salaries, 1981: Still Holding." In *Bowker Annual.* 28th ed. New York: Bowker, 1983: 279-294.

Continues annual salary survey. Reports no dramatic changes; mean beginning salaries for women, $15,478 and for men, $16,516. Adaptation of [1982-122].

1983-19 *Library Human Resources: A Study of Supply and Demand.* Washington, D.C.: Govt. Print. Off., 1983. Prepared for the National Center of Education Statistics by King Research, Inc., Nancy K. Roderer, Project Director. (NCES 83-207)

Examines supply and demand in the library and information professions between 1955 and 1981 and projected to 1990. Table 5 (p. 31) shows degrees awarded by accredited MLS programs, by sex, 1974-1980; and Table 14 (p. 41) shows number of employed librarians, by sex and type of library, January 1982. Degrees are awarded almost uniformly to four times as many women as men. Percentages in employment show the most women in school libraries (91 percent) and the fewest in academic libraries (65 percent).

1983-20 Phenix, Katharine. "Analysis of the 1981/82 HEGIS/LIBGIS Responses of Illinois Academic Libraries." Springfield, Ill.: Illinois State Library, 1983.

Includes salary and position data on Illinois academic librarians by sex. Also available as ERIC document ED 238 428.

1983-21 Posey, Joye D. "Mentoring of Male and Female Library Directors and Career Advancement." Master's paper, University of North Carolina, Chapel Hill, 1983.

No significant differences by sex were found in this sample.

1983-22 Razzouki, Naima Hassan. "The Academic Librarian's Attitude Toward Librarianship in the Tri-State Area: Pennsylvania, Ohio, and West Virginia." Ph.D. thesis, University of Pittsburgh, 1983. (DAI DA85-01902)

A study of attitudes, with sex as a variable, showed that "the relationship between the demographic variables and the attitudes toward librarianship showed no significant differences except for salary satisfaction."

1983-23 *Report of the Task Force on Library and Information Services to Cultural Minorities.* Washington, D.C.: Govt. Print. Off., 1983. (Y3.L61: 2L 61/4)

Section on library personnel (p. 12) reinforces information that the library profession is predominantly white, middle-aged, and female. Discussion of salaries (p. 14) points out that salary equity is more closely achieved between men and women and between minorities and whites at the entry level.

1983-24 Rosenquist, Kerstin. "The Professional Ethics of Librarians: A Finnish Version." *Scandinavian Public Library Quarterly* 16 (1983): 30-33.

Notes that the profession is female dominated and underpaid.

1983-25 *Salary Survey: Connecticut Public Libraries, 1982.* Hartford, Conn.: Connecticut State Library, September 1983.

Tables break out 1982 salary information by sex. For example, the salary-ranges listing of public library directors shows the seventy-six women to be making $8,000 to $38,000 while forty-one male directors earn $9,013 to $45,513. Average salary for men who reported a salary was $23,992, for women $17,482.

1983-26 *SLA Triennial Salary Survey.* New York: Special Libraries Assn., 1983.

Presents number of respondents and mean, median, and percentile salaries, cross-tabulated by sex, census division, type of employer, etc. Mean salary for men in the United States was $29,031, for women, $22,485.

1983-27 U.S. Library of Congress. *Librarian of Congress's Annual Report 1982.* Washington, D.C.: Govt. Print. Off., 1983. (LC 1.1: 982)

Describes Women's Program activities as well as various Equal Employment Opportunity Programs.

1983-28 Wilkes, Adeline Wood. "A Study of Managerial Functions Performed by Beginning Academic Librarians and Their Perception of Their Preparation for These Responsibilities." Ph.D. thesis, Florida State University, 1983. (DAI AAD83-25690)

Male and female librarians have different perceptions of their preparation for one out of ninety-nine administrative activities listed.

1983-29 Barker, Margaret M. "ALA and the ERA." *American Libraries* 14 (January 1983): 12.

States that the writer resents one nickel of her money being spent on the ALA-ERA Task Force.

1983-30 Roberts, Norman, and Bull, Gillian. "Professional Education and Practice: A Survey . . . " *Journal of Librarianship* 15 (January 1983): 29-46.

Survey of past students of the Master's in Information Studies of the Post-Graduate School of Librarianship and Information Studies, University of Shef-

field. Attention is paid to first and current posts, duties involved, demands made on respondents, and skills acquisition. Table 12 (p. 45) breaks out respondents by sex, but not all analyses do.

1983-31 "You've Come a Long (?) Way, Baby." *LJ/SLJ Hotline* 12 (January 17, 1983): 4.

A help wanted ad from the *Atlanta Constitution* is described: "LIBRARIAN/ babysitter—Woman needed to check books and care for infant in professional design school. 4-6 hours/day."

1983-32 Fisher, Susan. "Women in Librarianship." *InCite* 4 (January 28, 1983): 13.

Advocates the establishment of a Standing Committee on the Status of Women in Librarianship to be appointed by the General Council of the Library Association of Australia.

Letter:

Small, Rhonda. "Women in Librarianship." *InCite* 4 (March 11, 1983): 2. Advocates concerted action in support of women in libraries and discusses the establishment of a Standing Committee on the Status of Women.

1983-33 Morris, Beryl. "Women in Senior Library Management." *Herald of Library Science* 22 (January-April 1983): 72-76.

Article reports on a management seminar held May 12, 1982, in London and sponsored by the Council of Polytechnic Libraries. Speakers included Sheila Ritchie and Rita Pankhurst. The purpose of the seminar was to look at the position of women in libraries, to analyze why women were not well represented in senior management, and to look at some possible ways of alleviating the latter.

1983-34 "Library Association Council 1983." *New Library World* 84 (February 1983): 20.

An analysis of certain characteristics of the fifty-nine members of the Council indicates that males outnumber females forty-seven to twelve.

1983-35 Siebert, W. S. "Sex and Family Status Differentials in Professional Earnings in the Case of Librarians." *Scottish Journal of Political Economy* 30 (February 1983): 18-41.

Reports the results of a survey of 2,622 Library Association members. Findings show that single men and women earn nearly the same, while married men earn much more and married women less. Therefore, the authors conclude that market discrimination is tied to family status rather than sex, with married men viewed as more reliable employees.

1983-36 Sonneman, Sabine, and L'Esperance, Jeanne. "A Case of Discrimination." *Canadian Library Journal* 40 (February 1983): 9-12.

History of the struggle of librarians and the events leading up to the Canadian

Human Rights Commission order to the Treasury Board to pay librarians salaries equal to historians because they perform work of equal value.

1983-37 "Women Bosses Share Wisdom." *American Libraries* 14 (February 1983): 88.
Reports panel presentation sponsored by the LAMA Women Administrators' Discussion Group.

1983-38 "Correction." *Library of Congress Information Bulletin* 42 (February 21, 1983): 66.
Table from [1982-131] is corrected.

1983-39 Bearman, David. "82 Survey of the Archival Profession." *American Archivist* 46 (Spring 1983): 233-241.
Demographic portrait of archivists includes age, sex, race, academic training, employment status, job title, the nature of the organizations worked in, professional involvement, and salaries. Tables show salaries by years of experience by sex (p. 240) and salaries by education by sex (p. 241).

1983-40 Bidlack, Russell E. "Some Economic and Demographic Realities Facing Library Education." *Public Library Quarterly* 4 (Spring 1983): 5-15.
Discussion of library school status notes that library school faculty have more women with high faculty rank than other disciplines who can fulfill affirmative action demands for women on university faculty committees.

1983-41 Hiatt, Peter. "Management Skills: Key to Better Service Delivery." *Journal of Library Administration* 4 (Spring 1983): 14-19.
Hiatt's discussion considers the background, basis, process, implications, and results of the University of Washington's Career Development and Assessment Center for Librarians.

1983-42 Hiatt, Peter. "Should Professionals Be Managers?" *Journal of Library Administration* 4 (Spring 1983): 21-39.
Results of findings from the Career Development and Assessment Center for Librarians are that women librarians who were assessed were generally unaware of their management potential, and their management skills typically exceeded their own expectations.

1983-43 Klett, Rex, and Seawell, Karen. "The Tar Heel Enclave: Public Library Salaries in North Carolina." *North Carolina Libraries* (Spring 1983): 15-22.
Depressed state of salaries of North Carolina public librarians and support staff is reviewed, as are reasons why these salaries have not kept pace with the higher cost of living. The problem is rooted in the fact that librarianship is a female-dominated profession. Solutions proposed include changing the public's perception of the library and improving librarians' self-image.

1983-44 Wong, William Sheh, and Zubatsky, David S. "The First-Time Appointed Academic Library Director 1970-1980: A Profile." *Journal of Library Administration* 4 (Spring 1983): 41-49.

Profile based on a survey of first-time directors finds sex differences in career patterns. Investigators recommend further studies of mobility and comparative careers.

1983-45 Bever, Diane. "Women in Indiana Libraries." *Focus on Indiana Libraries* 37 (March 1983): 9.

Programs at the Indiana Library Association's 1983 Annual Conference included a seminar on "The Woman Manager," conducted by Beverlee Anderson; an open program on "Status of Women—Career Patterns" with Kathleen M. Heim speaking; and a program on feminist literature.

1983-46 "Freshman Aim: Make Money." *American Libraries* 14 (March 1983): 120.

No men and only 0.1 percent of the women in a survey of freshmen indicated interest in library science as a possible field of study.

1983-47 "Winter Sunshine, Fiscal Gloom: ALA Meets in San Antonio." *Wilson Library Bulletin* 57 (March 1983): 559-565.

The candidates' debate before the SRRT Feminist Task Force is reported. Ella Gaines Yates and E. J. Josey's opinions on pay equity and affirmative action are noted.

1983-48 "Women's Concerns Task Force to Publish SHARE Directory." *InSRRTS* 5 (March 1983): 1.

Announces publication of *SHARE Directory* and other actions at the Feminist Task Force meeting at the 1983 Midwinter Conference.

1983-49 "Hay Associates San Jose Study Available." *LJ/SLJ Hotline* 7 (March 28, 1983): 4.

Suggests that the Hay report is an "invaluable model for any library with the need to document and appeal sex-related pay differentials."

1983-50 "Study of Part-time Employment at the Library of Congress 1975-1981." *Library of Congress Information Bulletin* 42 (March 28, 1983): 113-116.

Findings of a study by the Women's Program are reviewed in detail, notably that part-timers are primarily women.

1983-51 Bingley, Clive. "Personal Column." *New Library World* 84 (April 1983): 62.

Bingley notes that he has been requested to "belt up about the women's libbers."

1983-52 Murison, Jack. "Appointments, Sex, Time, and Chance." *New Library World* 84 (April 1983): 59-60.

Suggests that appointments to directorships are operated along the lines of a roulette game and that, currently, a man's chances are not really 5 to 1, but 3.1416 to 1.

1983-53 "Salary Survey Results." *MLA News* (May 1983): 1, 7-10.

Notes that the first MLA salary survey has recently been tabulated. Data show average mean salary in the United States for men at $29,031 and for women at $22,485. In Canada the average mean salary for male librarians is $28,140 and for females, $27,926.

1983-54 Wallace, Danny P. "83 Survey Sneak Preview." *Informant* 5 (May 1983): 14-17.

Analysis given includes data reported for head librarians and/or information center managers drawn from the 1983 Illinois State Library Survey of Special Libraries and Information Centers. Table 3 (p. 16) shows salary by sex.

1983-55 "Semiannual Report on Developments at the Library of Congress, October 1, 1982, Through March 31, 1983." *Library of Congress Information Bulletin* 42 (May 30, 1983): 173-188.

Developments in affirmative action and the Women's Program are described.

1983-56 Lumpkin, Julia L. "Women Librarians: Why and How to Get What You Want." *School Library Media Quarterly* 11 (Summer 1983): 311-315.

Describes the roles women in library and information work are taking on in power-building negotiation. Also provided are suggestions for positive action on the part of school library media professionals.

1983-57 Mahoney, Thomas A. "Approaches to the Definition of Comparable Worth." *Journal of Library Administration* 4 (Summer 1983): 87-100.

Reprinted from *Academy of Management Review* 8: 1 (1983). Traces the development of the concept of comparable worth and its application.

1983-58 Swisher, Robert D.; Smith, Peggy C.; and Boyer, Calvin J. "Educational Change Among Academic Librarians, 1973 and 1978." *Library Research* 5 (Summer 1983): 195-206.

Data collected from two sample surveys in 1973 and 1978 are analyzed. Change and direction of change in education for librarianship among ACRL academic librarians are examined. Table 3 (p. 201) breaks out by sex the highest degree currently held or being pursued. Authors write, "The most disconcerting finding to come out . . . is the disproportionately low percentage of female academic librarians holding or pursuing the second master's degree or the doctorate." Implications of this finding are discussed.

1983-59 Beresford, Joanna. "Unions and Librarianship." *New Zealand Libraries* 44 (June 1983): 31-33.

The fact that the majority of librarians in New Zealand are women is noted in

order to influence librarian participation in unions. Taking an active role in their appropriate trade union is cited as the best possible way for librarians to defend their interests as employees and as professionals.

1983-60 "Fairfax County Librarians File Pay Equity Complaint." *American Libraries* 14 (June 1983): 334.
Summarizes issues in this comparable-worth pay dispute.

1983-61 "Librarians Win $905,000" *American Libraries* 14 (June 1983): 337.
Settlement awards money to thirty-seven women librarians at University of Minnesota Twin Cities campus.

1983-62 "New Sexist Database for Female Librarians." *Online Review* 7 (June 1983): 200.
Review of Catalyst Resources for Women's data base describes its services as being "for female librarians."
Letters:
Ariel, Joan. "Letter." *Online Review* 7 (October 1983): 388. The report on the Catalyst Resources for Women's data base is criticized for its ignorance, bigotry, and sexism.
Broidy, Ellen. "Letter." *Online Review* 7 (October 1983): 387. Clarifies the meaning of sexism, identifies parts of the review as "inane and gratuitous," and chides author for comment about the name "Gurley."
Falk, Joyce Duncan. "Letter." *Online Review* 7 (October 1983): 387. Questions whether if a data base authored by someone named "Gurley" is for women, then is the Arthur D. Little data base for short librarians? Author is surprised and appalled by review.
Stewart, Alan K. "Letter." *Online Review* 7 (October 1983): 386. Calls article an "unfortunate blurb."
Turner, Gurley. "Letter." *Online Review* 7 (October 1983): 386. Registers "disappointment" over poor review. Notes that *Catalyst* has been "identifying and responding to critical employment issues for the past twenty-one years. . . . "

1983-63 "University of Minnesota Librarians Win Sex Bias Case." *Library Journal* 108 (June 1, 1983): 1072.
Twin Cities campus agrees to pay women $750,000 in back pay, to commit to salary equity, and to promote some women instructors to assistant professor rank.

1983-64 "Hiatt's Career Development and Assessment Center to Go National." *LJ/SLJ Hotline* (June 20, 1983): 4.
Describes national project for assessment centers to serve regions in the United States and Canada. Purpose is to encourage professional growth and management skills for women.

1983-65 Moore, May M. "New Blood and Managerial Potential in Academic Libraries." *Journal of Academic Librarianship* 9 (July 1983): 142-147.

Breakdowns by sex show male and female first-career, second-career, and alternative-career librarians by personality inventory. Negligible differences are found by sex.

1983-66 Bever, Diane. "Women Offer Help via Network." *Focus on Indiana Libraries* 37 (July-August 1983): 4.

Uses of the *Women in Indiana Libraries Network Directory* [1983-16] are discussed, with additional mention of information about networking and mentoring.

1983-67 Starr, Carol. "The Women's Issues Context." *American Libraries* 14 (July-August 1983): 484-485.

Highlights activities of women's groups at the ALA Annual Conference.

1983-68 Shaw, Renata. "Reports on the 74th Annual Conference of the Special Libraries Association, New Orleans, La., June 4-9, 1983." *Library of Congress Information Bulletin* 42 (August 1, 1983): 244-252.

Talks given by Laura Gasaway and Natasha Josefowitz on women and equal pay are reported.

1983-69 Coughlin, Caroline. "Current Personnel Issues." *New Jersey Libraries* 16 (Fall 1983): 1.

Overview of modern personnel management notes that feminists often become concerned "with the rights of all employees for a work environment supportive of human dignity and family life."

1983-70 Fitzgibbons, Shirley. "Children's Librarianship: The Unmet Personnel Needs." *New Jersey Libraries* 16 (Fall 1983): 9-17.

Indicates that children's librarianship is in a critical stage of development. Although women librarians historically have emphasized library services for children, children's librarians have suffered more heavily in the female-dominated professions. Author suggests an eleven-point program to assist children's librarians to assert themselves as involved professionals.

1983-71 Fulton, Betty F. "Access for Minorities and Women to Administrative Leadership Positions: Influence of the Search Committee." *Journal of the NANDAC* 47 (Fall 1983): 3-9.

This study focuses on search committees and their willingness to recommend minorities and women as chairpersons and deans. Responses to a questionnaire revealed that while search committees supported the candidacies of minorities and women, administrators frequently did not follow through with the appointment. Women and black administrators were clustered in positions such as head librarian, registrar, and director of financial aid.

1983-72 Goudy, Frank William. "Affirmative Action and Library Science Degrees: A Statistical Overview, 1973-74 Through 1980-81." *Journal of Library Administration* 4 (Fall 1983): 51-60.

Study focuses upon the ethnic and sex composition of master's degree recipients from ALA-accredited library education programs as well as those who earned doctorates in library science for the years from 1973 to 1974 and/or 1980 to 1981. Notes that white and Asian females continue to be overrepresented, although at the doctoral level there is a trend toward better representation of all racial, ethnic, and sex groups.

1983-73 Josephine, Helen B. "Women's Wages: Materials on Pay Equity." *Collection Building* 5 (Fall 1983): 68-72.

Good source material for the vertical file on pay equity.

1983-74A Maack, Mary Niles. "Introductory Remarks." *Journal of Library History, Philosophy, and Comparative Librarianship* 18 (Fall 1983): 369-371.

Notes that women's contributions to library history have often been overlooked and need to be "liberated" from undeserved obscurity. Articles in this issue stem from "Liberating Our Past," Research Forum of the American Library Association's Library History Round Table, Philadelphia, 13 July 1982.

1983-74B Grotzinger, Laurel A. "Biographical Research: Recognition Denied." *Journal of Library History, Philosophy, and Comparative Librarianship* 18 (Fall 1983): 372-381.

Analysis of biographical material about librarians attests to the need to restudy or reassess the role of women librarians for a clearer picture of library and social history.

1983-74C Hildenbrand, Suzanne. "Some Theoretical Considerations on Women in Library History." *Journal of Library History, Philosophy, and Comparative Librarianship* 18 (Fall 1983): 382-390.

Overviews the ways in which women have been written into history. Author suggests that there are many ways to a more liberating history than those that have been pursued by historians of librarianship to date. Also discussed are historiographic and professional problems that have confronted librarians attempting to write women into the history of librarianship in a truly liberating fashion.

1983-74D Brand, Barbara Elizabeth. "Librarianship and Other Female-Intensive Professions." *Journal of Library History, Philosophy, and Comparative Librarianship* 18 (Fall 1983): 391-406.

The histories of librarianship, teaching, nursing, and social work are compared. Strategies to cope with decreasing power for women in the semiprofessions are identified.

1983-74E Maack, Mary Niles. "Women Librarians in France: The First Generation." *Journal of Library History, Philosophy, and Comparative Librarianship* 18 (Fall 1983): 407-449.

Maack shows that by the mid-twentieth century, American librarianship had risen to first rank on the world library scene and, as such, served as a model for librarians and library development in France. Maack's research demonstrates that women entering librarianship in France at this time were highly intellectual and dynamic, and their activity accelerated professionalization and the development of library service.

1983-74F Dain, Phyllis. "Women's Studies in American Library History: Some Critical Reflections." *Journal of Library History, Philosophy, and Comparative Librarianship* 18 (Fall 1983): 450-477.

Dain's reflections form the introduction to the papers in this issue. Her essay is a series of meditations upon the theme of women in library history.

1983-75 Miller, Lynn; Dallas, Larrayne; and Johnson, Brenda. "A Long Way to Go: Feminist Personnel Issues." *New Jersey Libraries* 16 (Fall 1983): 1-6.

Some of the feminist concerns in libraries in the late 1960s and 1970s reviewed here are sex discrimination in hiring, promotion, salary equity, opportunities for attending conferences and meetings, benefits, institutional and interpersonal bias, the way women organize themselves to get their work done, mentoring and role modeling, and salaries. This overview focuses on post-Schiller research (1974-1983).

1983-76 Sharma, Prabha, and Wheelock, Gerald C. "An Examination of the Position of Female and Male Librarians in Academic Libraries in Alabama, Georgia, and Mississippi." *Southeastern Librarian* 33 (Fall 1983): 65-68.

Examines the characteristics of female and male academic librarians in Alabama, Georgia, and Mississippi. Demographics, education, professional activity, faculty rank, and benefits are presented in tabular form.

1983-77 Wiegand, Wayne A. "The Lion and the Lady Revisited: Another Look at the Firing of Mary L. Jones as Los Angeles Public Librarian in 1905." *Library and Information Science Research* 5 (Fall 1983): 273-290.

Reconstructs the record of events leading up to the dismissal of Mary L. Jones. Jones is portrayed as a victim of sex discrimination, but not quite as innocent as other historians have described.

1983-78 Moran, Barbara B. "Career Patterns of Academic Library Administrators." *College & Research Libraries* 44 (September 1983): 334-344.

Career progress of academic library administrators over a period of ten years is examined. Patterns are revealed by sex, suggesting that women and men must take different paths to the top. Several variables, including education, publication, personal and geographic differences, are studied. See [1982-27].

Letter:
Fatzer, Jill B. "To the Editor." *College & Research Libraries* 45 (May 1984): 226-227. Refutes findings, arguing that women are currently on a fast career track.

1983-79 "Washington Career Center Project Wins $22,477 Grant to Go National." *Library Journal* 108 (September 1, 1983): 1513.
Kellogg Grant is described for the national Career Development and Assessment Center for Librarians project.

1983-80 Learmont, Carol, and Van Houten, Stephen. "Placements and Salaries 1982: Slowing Down." *Library Journal* 108 (September 15, 1983): 1760-1766.
Reportage of sex and salary data for new graduates reveals women's mean salary at $16,335 and men's to be $17,641. Average salary is higher for men in every different type of library and information specialty.

1983-81 Pritchard, Sarah, et al. "Continuing Reports on the Annual Conference of the American Library Association, Los Angeles, California, June 25-30, 1983." *Library of Congress Information Bulletin* 42 (September 26, 1983): 333-336.
Activities of the SRRT Feminist Task Force and the Committee on the Status of Women are reported.

1983-82 "COSWL Reminds Members of Ongoing Nestle Boycott," *American Libraries* 14 (October 1983): 622.
The purpose of the 1980 resolution to boycott Nestle's products is reviewed.

1983-83 Lynch, Beverly, and Verdin, Jo Ann. "Job Satisfaction in Libraries: Relationships of the Work Itself, Age, Sex, Occupational Group, Tenure, Supervisory Level, Career Commitment, and Library Department." *Library Quarterly* 53 (October 1983): 434-447.
Reviews literature and reports on 1971-1972 study of staff in three university libraries. Analysis of data concludes that there was no significant difference between male and female employees and their job satisfaction.

1983-84 Nzotta, Briggs C. "The Literature on Librarians' Careers and Mobility in the U.S.A., U.K., and Nigeria." *International Library Review* 15 (October 1983): 317-334.
Although the author points out that few generalizations can be made from the literature, it is at least clear that in underdeveloped countries female librarians outnumber men and usually earn lower salaries.

1983-85 "SLA 1983 Salary Survey Update." *Special Libraries* 74 (October 1983): 390-391.
Updates of [1983-26]. Poll of 25 percent of Special Libraries Association members shows 8.7 percent increase in overall median salary since 1982.

1983-86 Shaw, Mike. "Polemic Parade: Verbal Flatulence Department." *State Librarian* 31 (November 1983): 37.

Editorial criticizes library employment advertisements that list in detail the various minorities from whom "applications are welcome." Shaw views the practice as patronizing, especially to women, assigning them "spurious individual status."

1983-87 Kilpela, Raymond. "A Profile of Library School Deans, 1960-81." *Journal of Education for Librarianship* 23 (Winter 1983): 173-192.

Profile of library school deans points out that the women deans are older, have higher education credentials, are promoted internally, and earn lower salaries than the men.

1983-88 Perlman, Nancy. "Pay Equity." *North Carolina Libraries* 41 (Winter 1983): 211-219.

This is a transcription of a speech delivered at the North Carolina Library Association's Biennial Conference, held October 26 to 28, 1983. The author notes four major types of comparable-worth activities: (1) state and local government job evaluation studies, (2) government commitment to close the wage gap between male- and female-dominated jobs and to establish the necessary legislative process, (3) bargaining and organizing—both union and nonunion, and (4) litigation. Several examples of librarian involvement in these activities are included.

1983-89 "ALA Executive Board Approves Hewitt Study." *Wilson Library Bulletin* 58 (December 1983): 249.

Support of Career Development and Assessment Center for Librarians national project is described.

1983-90 East, Harry. "Changes in the Staffing of U.K. Special Libraries and Information Services in the Decade 1972-1981: A Review of the DEC Census Data." *Journal of Documentation* 39 (December 1983): 247-265.

Although the numbers of women in management have increased, data gathered by sex of employee shows that 71 percent of library employees are female, but only 59 percent of professional positions are held by women. Also, data analyzed by sex and type of library show that men outnumber women in positions in national libraries.

1983-91 Monkhouse, Ted. "School Libraries: Statistically Speaking." *Canadian Library Journal* 40 (December 1983): 350-351.

Notes that the Canadian School Library Association's membership is 75.8 percent female and that this constitutes a factor that would dictate the types of programs the Canadian School Library Association (CSLA) should hold.

1983-92 Nelson, Milo. "No Friend of the Court or Cause." *Wilson Library Bulletin* 58 (December 1983): 245.

ALA Executive Board agrees that ALA counsel should issue "advisory statements" in the case of Glenda Merwine.

1983-93 "Part-time Work Patterns in Some Melbourne Academic Libraries." *Australian Academic and Research Libraries* 16 (December 1983): 229-231.

Report of results of a survey of permanent part-time employment in Melbourne university and college libraries. Table 2 (p. 231) shows numbers for male and female staff in 1979 and in 1982-83.

1983-94 Stein, Muriel L. "Speak Out Through Unions." *Library Journal* 108 (December 15, 1983): 2272.

Response to previous letter by Morten Eriksen Jr. (*Library Journal* 1983, May 15, p. 933) bemoaning low salaries in librarianship identifies female domination of the profession as the reason and advocates support of American Federation of State, County, and Municipal Employees (AFSCME) to raise salaries.

1984-01 Allan, Jane. "Not Fighting, But . . . " *Information and Library Manager* 3 (1984): 49.

Discusses negative and frustrating experiences of members of Women in Libraries during a presentation on the role of women in libraries at a library association meeting.

1984-02 Anisef, Paul, et al. *What Jobs Pay*. Edmonton, Alberta: Hurtig Publishers, 1984.

Quotes Norman Horrocks on "little old ladies of both sexes in tennis shoes" and suggests that men may compete for women's jobs.

1984-03 Freedman, Janet. "Empowering Librarians: A Study of the Women's Movement on the Careers, Work Modes, and Leadership Styles of Feminist Librarians." Ed.D. thesis, Boston University, 1984. (DAI DA84-06745)

Study concludes that feminist librarians have made substantial contributions to the creation of new work modes and styles of leadership within the library profession.

1984-04 Fretwell, Gordon. *ARL Annual Salary Survey 1983*. Washington, D.C.: Assn. of Research Libraries, 1984.

Table 12 includes distribution of professional staff in ARL university libraries by sex and position for the fiscal year 1984. There were seventy-six men and nineteen women in directorship positions. Table 13 breaks down number of staff and average salaries by sex, and Table 14 shows number of staff and average salaries of ARL minority librarians for fiscal year 1984, with data broken out by sex. In no case did women's average salaries equal or exceed those of men.

1984-05 Fretwell, Gordon. *ARL Annual Salary Survey 1984*. Washington, D.C.: Assn. of Research Libraries, 1984.

Table 12 includes distribution of professional staff in ARL university libraries by sex and position for fiscal year 1985. Tables 13 and 14 continue to report data on number of staff and average salaries, including information on ARL minority university librarians for fiscal year 1985. Data are broken out by sex. Tables 15 and 16 provide new information on number of staff and average years of experience. Data are broken out by sex, and ARL minority librarians are included in Table 16. Table 17 compares average salaries of men and women by years of experience.

1984-06 Frontain, Mona. "Women in Library Management." In *Festschrift in Honor of Dr. Arnulfo D. Trejo*. Edited by Christopher F. Grippo, et al. Tucson, Ariz.: Graduate Library School, University of Arizona, 1984: 213-220.

Discussion of the women's movement of the '70s and Patricia Glass Schuman's paper on "power" [1984-47] concludes with a summary of telephone interviews with women library managers Donna Tang and Betty Halpert.

1984-07 Greiner, Joy Marilyn. "A Comparative Study of the Career Development Patterns of Male and Female Library Administrators in Large Public Libraries." Ph.D. thesis, Florida State University, 1984. (DAI AAD85-03167)

Nationwide data on public library administrators are collected and analyzed. Shows that male directors are paid higher salaries than female directors and that the libraries they direct have more support than those directed by women. Dual career paths for women and men are identified, and mobility and networking are seen to be assets for men.

1984-08 Heim, Kathleen M., and Phenix, Katharine. *On Account of Sex: An Annotated Bibliography on the Status of Women in Librarianship 1977-1981*. Chicago: American Library Assn., 1984.

Bibliography continues in the fashion of its predecessor, *Role of Women in Librarianship 1876-1976: The Entry, Advancement, and Struggle for Equalization in One Profession* by Kathleen Weibel and Kathleen M. Heim, with assistance from Dianne J. Ellsworth [1979-28]. The Introduction provides a comprehensive survey of the activities of women's groups within librarianship. The citations themselves are annotated to assist researchers in deciding whether or not an item should be retrieved for closer inspection. The book is indexed in three separate indexes. The most comprehensive tool in the field of gender as it affects librarianship.

Reviews:

AB Bookman's Weekly 77 (March 24, 1986): 1330.

Blake, Fay. "Women's Status in Libraryland." *Library Journal* 109 (September 1984): 1738.

Bowman, Maureen. *The Journal of Academic Librarianship* 10 (September 1984): 250.

Bristo, Catherine. *Canadian Library Journal* 43 (February 1986): 68-69.

Loeb, Catherine R. *American Reference Books Annual 1985*. Littleton, Colo.: Libraries Unlimited, 1985. This review also appears in *Library Science Annual*, vol. 1. Littleton, Colo.: Libraries Unlimited, 1985: 98-99.

Phenix, Katharine. "Women in Librarianship: Research." *WLW Journal* 9 (July/September 1984): 23.

Wert, Lucille M. *Journal of Library History, Philosophy, and Comparative Librarianship* 21 (Fall 1986): 788-789.

1984-09 Heintze, Robert A. National Center for Education Statistics. *Library Statistics for Colleges and Universities 1982*. Washington, D.C.: Govt. Print. Off., 1984. (ED1. 122/3: 982)

Data derived from the NCES survey of college and university libraries conducted in fall 1982. Gives information on full-time-equivalent staff by sex and by hours of student assistance, 1979-1982 (Table D, p. 4) and on number and percent of full-time-equivalent professional and nonprofessional staff by sex and by institutional control, type, and size, fall 1982 (Table 1.25).

1984-10 Henderson, Carolyn. "Personnel and Employment: Recruitment and Selection." In *ALA Yearbook of Library and Information Services '84*. Edited by Robert Wedgeworth. Chicago: American Library Assn., 1984: 222.

Reviews the literature of three years, citing comparable worth as the key issue.

1984-11 Ivy, Barbara Anne. "Academic Library Administration: Power as a Factor in Hiring and Promotion within a Feminized Profession." Ph.D. thesis, University of Pittsburgh, 1984. (DAI AAD84-21296)

Power in previous position is looked at as a variable used when interviewing for a new position. Study suggests that women place less emphasis on power within the profession than men and that the search process in large institutions places importance on this kind of power. This may explain why there are fewer women in top administrative positions in academic libraries.

1984-12 Johnson, Richard D. "Academic Libraries." In *ALA Yearbook of Library and Information Services '84*. Edited by Robert Wedgeworth. Chicago: American Library Assn., 1984: 40-41.

Personnel section reports on salaries, indicating that annual averages for men are about $1,200 more than for women. The Merwine case and the University of Minnesota discrimination complaint are also mentioned.

1984-13 Learmont, Carol L., and Van Houten, Stephen. "Placements and Salaries, 1982: Slowing Down." In *Bowker Annual*. 29th ed. New York: Bowker, 1984: 307-321.

Adaptation of [1983-80] shows beginning-level salary of both men and women as $16,583.

1984-14A Moore, Kathryn M. "Careers in College and University Administration: How Are Women Affected?" In *Women in Higher Education Administration*. New Directions for Higher Education, no. 45. Edited by Adrian Tinsley, et al. San Francisco: Jossey-Bass, 1984: 5-15.

Survey of college and university administrators points out that the three administrative positions that employ the largest number of women are head librarian, registrar, and financial aid director.

1984-14B Tinsley, Adrian. "Career Mapping and the Professional Development Process." In *Women in Higher Education Administration*. New Directions for Higher Education, no. 45. Edited by Adrian Tinsley, et al. San Francisco: Jossey-Bass, 1984: 17-24.

Introduction notes that library director is one of the three university administrative positions, along with registrar and financial aid director, that are most often held by women. Discusses the Summer Institute for Women in Higher Education, which included librarians as participants.

1984-15 Moran, Barbara B. *Academic Libraries: The Changing Knowledge Centers of Colleges and Universities*. ASHE-ERIC Higher Education Research Report No. 8. Washington, D.C.: Assn. for the Study of Higher Education, 1984.

Includes brief discussion of the position of women in academic libraries (p. 58). Notes that although academic librarianship has a higher proportion of males than any other type of librarianship, approximately 65 percent of academic librarians are women. Points out that men hold the leadership roles and women the subordinate positions, but notes that anecdotal evidence suggests that the position of women in academic libraries is improving.

1984-16 Munford, W. A. "Prospect and Prejudice, or Women in Librarianship 1880-1914: Three Footnotes." *Library History* 6 (1984): 181-183.

Adds information about Mary Petherbridge and James Duff Brown. See Webber [1984-40].

1984-17 Murdoch, Sheila. "Where There's a Will . . . " *Not the Library Association Record* 1 (1984): 7.

A call to join Women in Libraries, a "nationwide pressure group," to improve the position and highlight the role of all women who work in libraries.

1984-18 Ostendorf, Paul John. "The History of the Public Library Movement in Minnesota from 1849 to 1916." Ph.D. thesis, University of Minnesota, 1984. (DAI AAD84-13812)

Study documents the exceptional leadership of women in the public library movement in Minnesota. Of special note is the fact that women were granted the right to vote on library matters.

1984-19 Phenix, Katharine. "Women in Librarianship." In *ALA Yearbook of Library and Information Services '84*. Edited by Robert Wedgeworth. Chicago: American Library Assn., 1984: 289-293.

Reviews major publications, surveys, association activities, and salary data available for the year on the status of women in librarianship.

1984-20 Phenix, Katharine. "Women Predominate, Men Dominate: Disequilibrium in the Library Profession." In *Bowker Annual.* 29th ed. New York: Bowker, 1984: 82-89.

A summary of the history of activist women in librarianship, a survey of published research on women in the library profession, and a description of some new approaches toward redressing inequalities make up this essay.

1984-21 Potter, Janet L.; Gavryck, Jacquelyn; and Wells, Margaret. *State University of New York Librarians' Association Salary Survey.* Arlington, Va.: ERIC Document Reproduction Service, 1984. (ED 148 348)

Data as of December 1983 are presented in several tables that break out staffing information by sex. For example, the twenty-two male directors earned $41,510, while the five female directors earned $40,604, even though the women averaged 22.4 years of experience to men's 21.3 years. All tables show a male advantage.

1984-22A Purcell, Gary R. "Faculty." In *Library and Information Science Statistical Report 1984.* State College, Pa.: Assn. for Library and Information Science Education, 1984: F1-F86.

Composition of library school faculty and salary data are analyzed for the eleventh year. Tables and descriptions make up most of the report. Much of the data are broken out by sex, and women still lag behind. Author provides some analyses on this topic.

1984-22B Reagan, Agnes L. "Students." In *Library and Information Science Educational Statistical Report 1984.* State College, Pa.: Assn. for Library and Information Science Education, 1984: S1-S65.

Master's students officially enrolled full time in the fall 1984 term numbered 2,495 women and 785 men at the sixty-four library schools reporting. At the doctoral level there were seventy-one men and 112 women in the twenty-three schools that reported. Also includes a profile of the student body by sex and ethnic origin and by age and sex. Includes information on scholarships and assistantships awarded by amounts, sex, and program level for 1982-1983.

1984-23 Query, Lance. "Personnel and Employment: Compensation." In *ALA Yearbook of Library and Information Services '84.* Edited by Robert Wedgeworth. Chicago: American Library Assn., 1984: 220-221.

Reportage of salary surveys includes some income averages by sex. Pay parity information is treated in a concluding paragraph.

1984-24 Saunders, LaVerna. "In Search of Excellence in Academic Libraries." In *Feminist Pedagogy and the Learning Climate.* Edited by Katherine Long.

Bethesda, Md.: ERIC Reproduction Service, 1984. (ED 252 493)

Research on the career paths and salaries of women in library management and in academia are summarized. Women are urged to develop their own networks and flexible, equitable organizational models to succeed and to change how libraries are managed.

1984-25 Sellen, Betty-Carol, and Vaughn, Susan J. "A Survey of Librarians in Alternative Work Places." In *New Options for Librarians: Finding a Job in a Related Field.* Edited by Betty-Carol Sellen and Dimity S. Berkner. New York: Neal-Schuman, 1984: 3-28.

Describes results of survey of individuals with library school credentials but employed outside of traditional library settings. Of 487 usable questionnaires, 374 (76.8 percent) were from women.

1984-26 Shuter, Janet. *Women and Librarianship.* Bradford: MCB University Pr., 1984.

A collection of essays on the topic of women and librarianship in Great Britain. The collection also appears in *Library Management* (1984) as vol. 5. [1984-27A-G].

Review:

Darter, Pat. "Required Reading." *Library Association Record* 87 (August 1985): 307.

1984-27A Shuter, Janet. "Introduction." *Library Management* 5 (1984): 3-8.

Introduces articles about women in librarianship in the United Kingdom. Articles focus on feminists in education and the workplace, and the status of women in the profession. Reviews statistics on representation of women in libraries, salaries, and status, and discusses "disabilities" (characteristics that disadvantage women) and overt discrimination.

1984-27B Fawcett, Helene. "The School, the Library, and the Feminist." *Library Management* 5 (1984): 9-16.

Examines the role of the feminist in school librarianship and the status and problem of librarians and libraries in schools.

1984-27C Redfern, Margaret. "Feminism and Education for Library and Information Work." *Library Management* 5 (1984): 23-29.

Discusses library school curriculum and the need for it to reflect status issues and services to women. Also expresses concern for involvement and education of feminist support staff.

1984-27D Burrington, Gillian A. "The Perceived Role and Status of Women in U.K. Librarianship." *Library Management* 5 (1984): 32-37.

Research on women librarians' perception of their status is reported. Concludes that women are paid less and have positions of lower status primarily because both men and women in libraries reinforce gender norms. Suggests strategies to change perceptions and improve women's status.

1984-27E Ritchie, Sheila. "Women in Libraries: Status and Orientation to Work." *Library Management* 5 (1984): 37-45.

Reports data on the status of women in U.K. libraries; describes problems in researching causes rather than effects of low status and suggests strategies for improving status.

1984-27F Rolph, Avril V. "The Power of Women in Libraries." *Library Management* 5 (1984): 46-59.

Traces the history of the Women in Libraries organization.

1984-27G Ward, Patricia Layzell. "Working Your Way Up the Ladder: An Updating of Advice to Women Librarians and Information Managers." *Library Management* 5 (1984): 60-64.

Suggests action, strategies, and skills for women interested in library management positions.

Review:

Steele, Colin, and Henty, Margaret. "A Woman's Place Is in the Library? A Review Article." *Journal of Librarianship* 19 (April 1987): 121-128.

Darter, Pat. "Required Reading." *Library Association Record* 8 (August 1985): 307.

1984-28 U.S. Department of Commerce. Bureau of the Census. *U.S. Census of Population 1980: Vol. 1. Characteristics of the Population, Chapter D. Detailed Population Characteristics*. Washington, D.C.: Govt. Print Off., 1984. (C3.223/8: 980/D(1-B)) (2531-4 ASI 1983, 1984)

Several tables include data on librarians by sex.

1984-29 U.S. Department of Commerce. Bureau of the Census. *U.S. Census of Population 1980: Vol. 2. Subject Reports. Occupation by Industry*. Washington, D.C.: Govt. Print. Off., 1984.

Final table includes librarians, archivists, and curators by sex.

1984-30 U.S. Department of Commerce. Bureau of the Census. *U.S. Census of Population 1980. Supplementary Reports. Detailed Occupation of the Experienced Civilian Labor Force by Sex for the U.S. and Regions: 1980 and 1970*. Washington, D.C.: Govt. Print. Off., 1984. (C3.223/12: 980/51-15) (2535-1.12 ASI 1984)

The percentages of women in the library profession in 1970 and in 1980 are provided; the report also breaks down the percentages of women in the library profession throughout the United States and in four geographic regions.

1984-31 U.S. Department of Commerce. Bureau of the Census. *We, the American Women*. Washington, D.C.: Govt. Print. Off., 1984. (C3.2: Am3/6/No.2)

Contains a table (p. 8) that highlights selected occupational groups of women.

1984-32 U.S. Department of Education. National Center for Education Statistics. *The Condition of Education, 1984*. Washington, D.C.: Govt. Print. Off., 1984.

Table 2:13 "Percent of Earned Degrees Awarded to Females by Institutions of Higher Education by Level of Degree and Discipline Division" includes librarianship.

1984-33 U.S. Department of Education. National Center for Education Statistics. *Library Statistics of College and University Libraries, 1982.* Washington, D.C.: Govt. Print. Off., 1984. (ED1.122/3: 982) (4858-10 ASI 1985)

Triennial report of expenditures, holdings, staff, and operations of college and university libraries. Includes number and percent of full-time and full-time equivalent (FTE) staff by sex.

1984-34 U.S. Department of Education. National Center for Education Statistics. *Three Years of Change.* Washington, D.C.: Govt. Print. Off., 1984. (L2.3: 2206) (6744-3 ASI 1984)

Data on staff appears on page 6.

1984-35 U.S. Department of Labor. *Occupational Outlook Handbook 1984-85.* Washington, D.C.: Govt. Print. Off., 1984. (L2.3/4: 985-85) (6744-1 ASI 1984)

Librarian in photo is female, as usual.

1984-36 U.S. Department of Labor. Bureau of Labor Statistics. *Occupational Projections and Training Data, 1984.* Washington, D.C.: Govt. Print. Off., 1984. (L2.3: 2206) (6744-3 ASI 1984)

Section "Characteristics of Entrants" notes that "most librarians are women, and the occupation is characterized by movement from employment to family responsibilities and back again. Most job openings are filled by homemakers returning to the labor force."

1984-37 U.S. Department of Labor. Women's Bureau. *Time of Change: 1983 Handbook on Women Workers.* Washington, D.C.: Govt. Print. Off., 1984. (L36.103: 298)

Contains statistical data relevant to the status of women in librarianship.

1984-38 U.S. Library of Congress. *Librarian of Congress Annual Report 1983.* Washington, D.C.: Govt. Print. Off., 1984. (LC 1.1: 983)

Describes activities of the Women's Program and Equal Employment Opportunity programs.

1984-39 U.S. Office of Personnel Management. *Occupations of Federal White-Collar and Blue-Collar Workers: Federal Civilian Workforce Statistics.* Washington, D.C.: Govt. Print. Off., 1984. [PM #1.10/2: OC1/3/983] (9844-4 ASI 1985)

While this publication describes some library positions with salaries listed by sex, the Library of Congress is not included.

1984-40 Webber, Nigel. "Prospect and Prejudice: Women and Librarianship, 1880-1914." *Library History* 6 (1984): 153-162.

Women entering the field in Great Britain were welcomed with sentiments such as "a man's strength and energy are wasted on such quiet work for which any refined woman of business habits is better fitted" (p. 157). Points out restrictions against women entering librarianship in large numbers: among them lack of institutions offering education to women and constraining dress styles.

1984-41 Welmaker, Roland Bernard. "The Relationships of Perceived Management Systems and Job Satisfaction of Public Librarians." Ph.D. thesis, University of Michigan, 1984. (DAI 85-02950)

No significant difference in job satisfaction by sex; however, males perceived themselves to be in more participative settings than women, whereas women tended to be more satisfied with their jobs.

1984-42 Berry, John. "Rewriting the Future." *Library Journal* 109 (January 1984): 2.

Notes Schuman's call [1984-47] to "rewrite the terms of power."

1984-43 Golrick, Jill. "Status and Economic Interests of Health Science Library Personnel." *Bulletin of the Medical Library Association* 72 (January 1984): 117.

Describes design and distribution of the MLA salary survey. Mentions that pay equity issues will be considered as part of the survey study and as a matter for future action.

1984-44 "Library School Trends in 1983: Taking in Sail and 'Graying.'" *Library Journal* 109 (January 1984): 20.

ALISE statistical report is described. Points out that women deans and directors are paid approximately $7,000 less than men in similar positions.

1984-45 Nyren, Karl. "News in Review, 1983." *Library Journal* 109 (January 1984): 27-41.

Mentions salary discrimination cases by the University of Minnesota and Fairfax County, Virginia, public librarians.

1984-46 Olsgaard, John N. "Characteristics of 'Success' Among Academic Librarians." *College & Research Libraries* 45 (January 1984): 5-14.

Who's Who in Library and Information Services provides sample data for "success" measurement. Demographic data related to gender indicate that men have a better chance to succeed as determined by educational qualifications, employment, and publication activity.

1984-47 Schuman, Patricia Glass. "Women, Power, and Libraries." *Library Journal* 109 (January 1984): 42-47.

Defines power, its sources, and its uses from various sociological, psychological, and economic perspectives and applies the discussion to the

status of women in libraries—a powerless group in a powerless profession. Suggests redefining power as "the ability to get cooperation" and advocates that women work to change the existing hierarchical power structure through networking, legal action, and consciousness raising.

Letters:

Daehler, Russ. "Painting Their Faces." *Library Journal* 109 (April 15, 1984): 744. Criticizes Schuman for "missing the obvious"—that "women do not lack power because of biology, but because of sociology."

Baker, Connie. "Not One Russ Could Shove." *Library Journal* 109 (August 1984): 1354-1365. Criticizes interpretation of "female appearance, grooming, manners" as feminine passivity.

1984-48 Nzotta, Briggs C. "Geographic Mobility of Public Librarians in Nigeria." *Herald of Library Science* 23 (January/April 1984): 6-16.

Librarians and job-changing patterns are surveyed. Mobility of women respondents was most often tied to "their desire to avoid separation from their husbands," or, secondarily, for reasons of job satisfaction rather than salary or career advancement.

1984-49 Robinson, Liz. "Vital Statistics." *SLA News*, no. 179 (January/February 1984): 19-20.

Editorial comments on the stereotypical librarian and attributes such typing to the "long and continuing predominance of men in positions of power." Proposes that we look "behind the facade" to change these stereotypes.

1984-50 "Centers for Career Help Proposed." *American Libraries* 15 (February 1984): 104.

Career Development and Assessment Center for Librarianship regional centers proposal submitted to W. K. Kellogg Foundation is described to LAMA Women Administrators' Discussion Group.

1984-51 "Judge Reverses Jury Decision in Mississippi Sex-Bias Case, Recognizes ALA-MLS Degree." *American Libraries* 15 (February 1984): 72.

Merwine case is summarized.

1984-52 Agada, John. "Studies in the Personality of Librarians." *Drexel Library Quarterly* 20 (Spring 1984): 24-45.

The literature of personality studies is reviewed, and a brief overview of the theories of personality is presented. Many of the studies cited compare traits of male and female librarians.

1984-53 Schmidt, Karen. "The Other Librarians: Undergraduate Library Science Programs and Their Graduates." *Journal of Education for Librarianship* 24 (Spring 1984): 223-232.

Of 227 undergraduate librarians, 86.8 percent are women.

1984-54 Smith, Howard L., and Reinow, Frank. "Librarians' Quality of Work Life: An Exploration." *Journal of Library Administration* 5 (Spring 1984): 63-76.

Women supervisors from New Mexico libraries are surveyed to determine job satisfaction, job tension, organizational commitment, and organizational climate. No comparisons are made with men in similar positions.

1984-55 "Anti-Nestle Boycott Ends." *American Libraries* 15 (March 1984): 129.

ALA Committee on the Status of Women in Librarianship no longer need monitor the Nestle boycott begun in 1980.

1984-56 Balcolm, Ted. "Social Responsibilities Round Table." *Illinois Libraries* 66 (March 1984): 143-144.

ILA-SRRT projects include the Women's Concerns Task Force work on the 1984 *SHARE Directory* and the Chicago 1992 Women's Fair.

1984-57 "Feminist Library Workers." *American Libraries* 15 (March 1984): 184.

Advertises Illinois Library Association Women's Concerns Task Force edition of the *SHARE Directory*.

1984-58 Kelly, N. "Visions." *New Library World* 85 (March 1984): 43-44.

Commentary listing several "visions" of librarianship in the future includes sex and pay equity, raised consciousness among library staff, and innovative library management and job structures.

1984-59 Nelson, Dale. "High Value on Women's Work (Sex Discrimination)." *Wilson Library Bulletin* 58 (March 1984): 494-495.

Reviews comparable-worth activities and salary studies as they affect librarians.

1984-60 Smith, Karen F., et al. "Tenured Librarians in Large University Libraries." *College & Research Libraries* 45 (March 1984): 91-98.

Sixty-one percent of librarians of the 530 surveyed in thirty-three academic libraries were women. Results of professional activity, pre- and post- tenure, and tenure criteria and evaluation are discussed.

1984-61 "Comparable Worth Ruling Compliance Advised by Report." *Library Journal* 109 (March 1, 1984): 412.

Reports on Washington State Court ruling requiring the state to spend $225 million in salary adjustments to female-dominated nonacademic jobs in higher education institutions.

1984-62 "ALISE in Washington." *Library Journal* 109 (March 15, 1984): 541-542.

Describes presentations by library administrators on "Getting to the Top."

Speakers Patricia Battin, Merrily Taylor, and Nancy Eaton focused on career planning, mentoring, and politics.

Letter:

Intner, Sheila. "Women at ALISE." *Library Journal* 109 (June 15, 1984): 1158. Notes that the article fails to mention Women in Librarianship Special Interest Group as the sponsor.

1984-63 Levy, David. "A Man Looks at the Women's Program." *Library of Congress Professional Guild Newsletter* 9 (March-April 1984): 4-5.

Opinion column criticizes Library of Congress Women's Program Advisory Office for practicing reverse sexism by slighting needs of men.

Letter:

Pritchard, Sarah. "Are Men Oppressed?" *Library of Congress Professional Guild Newsletter* 9 (July-August 1984): 5-6.

1984-64 "ALA Elections: 1984." *American Libraries* 15 (April 1984): 256-258.

Presidential debate between Lynch and Mathews includes comments about representation of women on ALA Council.

1984-65 Barker, Keith. " 'A Library Life for Deborah' Revisited." *New Library World* 85 (April 1984): 63-64.

Thoughtful review of a 1957 publication by Joan Llewelyn Owens analyzes librarianship and women's attitudes toward a career as viewed thirty years ago.

1984-66 "Chapter News." *College & Research Libraries News* 45 (April 1984): 189.

New Jersey Library Association program "Myths/Realities of Academic Women Librarians," with presentations by Dee Garrison, Patricia Glass Schuman, and Leigh Estabrook, is announced.

1984-67 Hutchinson, Joseph A., and Ranking, Pauline. "Survey of Salaries, Education, and Funding in Instructional Technology." *Instructional Innovator* 29 (April 1984): 14-35.

Fifteen percent of Association for Educational Communications and Technology (AECT) members polled showed men composed 64 percent of the membership, were better educated, and were older on the average than the women. Men also earned approximately $4,000 more than women. Sexual distribution by job classification indicated that men and women occupied the position of Library and/or Information Specialist nearly equally.

1984-68 Mech, Terrence. "Ohio's Small Private College Library Directors." *Ohio Library Association Bulletin* 54 (April 1984): 20-23.

Reports on a survey of twenty-seven library directors (eighteen men and nine women). Results showed that men directors were, on the average, older than the women, had more years of administrative experience, and had worked in their present positions longer. Women directors were more mobile.

1984-69 Swisher, Robert, and DuMont, Rosemary Ruhig. "Sex Structuring in Academic Libraries: Searching for Explanations." *Library Quarterly* 54 (April 1984): 137-156.

Analysis of survey data of 350 academic librarians concludes that even when professional characteristics are equal, women do not hold administrative positions in proportion to their numbers. Sex structuring phenomena are described as "filters."

1984-70 "Court Orders Tenure Be Granted to University Minn. Librarian." *Library Journal* 109 (April 1, 1984): 618.

Reports University of Minnesota required to grant tenure to Linda DeBeau-Melting, the librarian who filed a sex discrimination complaint after being denied tenure in 1980.

1984-71 McGraw, Roberta S. "Poverty Wages for Women." *Library Journal* 109 (April 1, 1984): 610.

Criticizes salaries listed in *Library Journal* classified ads as communicating "that a woman must either be satisfied with poverty wages and look for a man to support her or get out of the library field."

Letters:

Parris, Lou B., and Worley, Penny. "Mobility, Not Gender." *Library Journal* 109 (July 1984): 1269. "Capitalizing on opportunities" in a "limited field" such as librarianship is seen as a personal choice and not gender-mandated.

Wheeler, Helen R. "Salary Sexism." *Library Journal* 109 (August 1984): 1364. Notes that many job listings indicate no salary level, which contributes to a "potentially discriminatory" salary negotiation for women.

1984-72 "Status of Women in Librarianship Special Interest Group." *InCite* (April 6, 1984): 6.

Discusses establishment, programs, and objectives of this section of the Library Association of Australia.

1984-73 "Comparable Worth Study Upgrades Oregon Librarians." *Library Journal* 109 (April 15, 1984): 751.

Douglas County comparable-worth study of librarians resulted in increased salaries and a new starting-salary range.

1984-74 "Career Development Needs and Plans: Study." Chicago, Ill.: Chicago Consulting Center, May 1984.

Report prepared by the Chicago Consulting Center (CCC) in order for ALA to determine career-related problems and career development needs of member librarians. Breaks down responses by sex. (Major findings summarized in March 11, 1983, report).

1984-75 Holley, Edward G. "The Merwine Case and the MLS: Where's ALA?" *American Libraries* 15 (May 1984): 327-330.

Reviews the recent history of the ALA-accredited MLS as a minimum job qualification, details the Merwine case, and describes Holley's testimony as an expert witness on behalf of the MLS. Criticizes ALA for not coming to the defense of the degree.

1984-76 Van Boxem, Mie. "Openbaar Bibliotheekwerk-Vrouwenwerk?" *Bibliotheek-en Archiefgids* 60 (May 1984): 114-129.
Title translates to "Public Library Work. . .Women's Work?"

1984-77 "New Developments in Equal Employment Opportunity." *Library of Congress Information Bulletin* 43 (May 7, 1984): 152-156.
Activities of the Women's Program Office and the LC Affirmative Action Office are reported.

1984-78 "Women in Certain Management Positions." *Library of Congress Information Bulletin* 43 (May 7, 1984): 155.
Description of women in certain management positions is accompanied by a table that updates [1983-50] and displays numbers and percentages of women in management positions from 1977 to 1983. In no case does women's representation exceed 48 percent.

1984-79 "Workforce Utilization Analysis: An Update for Fiscal Year 1984." *Library of Congress Information Bulletin* 43 (May 21, 1984): 168-170.
LC's affirmative action plan and its analysis of underrepresentation of women and minorities are reported.

1984-80 Goggin, Jacqueline. "The Feminization of the Archival Profession: An Analysis of the 1982 Salary Survey As It Pertains to Women." *American Archivist* 47 (Summer 1984): 327-330.
Survey of 1,717 Society of American Archivists members reveals that women earn 25 percent less than men and that differentials are largest for those employed longest. Twice as many women enter the profession, while men over fifty years old are leaving in greater numbers. Men are better educated than women, and more young women are entering the profession with only a bachelor's degree. Author expresses concern that these factors combined will detrimentally affect pay equity efforts. Encourages wider distribution of the survey and additional questions regarding the status of women.

1984-81 Green, Madeleine F. "Women and Minority ACE Fellows in the Ascent Toward Administrative Posts." *Educational Record* (Summer 1984): 46-49.
A survey of 4,000 administrators shows a concentration of women as library administrators, registrars, and financial aid directors. Describes American Council on Education (ACE) Fellows Program designed to identify and train female and minority administrators and provide statistics and placement information on program participants.

1984-82 Maggio, Theresa E. "Role of Women Directors in Louisiana's Public and Academic Libraries." *Louisiana Library Association Bulletin* 47 (Summer 1984): 19-22.

Survey of sixty-five public and thirty-nine academic libraries traces the history of directorships from 1930 to the present. Results show that women are still in the majority in public libraries except in larger, urban libraries. In academic libraries, women gained during the '30s, but numbers have declined in every decade since then, except for a light upswing in 1983.

1984-83 "Results of Opinion Surveys Presented at AASL Membership Meeting in Dallas." *School Library Media Quarterly* 12 (Summer 1984): 330-335.

Report of a survey of the American Association of School Librarians reveals that the typical member is a female school media specialist.

1984-84 "ALA Favors Pay Equity Bills, Rejects OPM Monitoring." *American Libraries* 15 (June 1984): 361.

ALA Washington Office staffer Eileen Cooke's letter to Representative Mary Rose Oakar in support of pay equity is excerpted.

1984-85 Lange, Pamela, and Shields, Gerald. "Dallas Public Library: A Reputation for Excellence." *Wilson Library Bulletin* (June 1984): 703-707.

Mentions that Ms. Bradshaw was the first married woman to be hired by the Dallas Public Library, the first woman department head, and the first woman president of the American Library Association.

Letter:

Rheay, Mary Louise. "Remembering the Ladies." *Wilson Library Bulletin* 59 (October 1984): 86+. Corrects number of women presidents of ALA.

1984-86 Mellor, Earl F. "Investigating the Differences in Weekly Earnings of Women and Men." *Monthly Labor Review* 107 (June 1984): 17-28.

Librarians, archivists, and curators are included in an occupational category.

1984-87 Rockman, Irene. "Job Satisfaction? How Autonomy, Decision-making Opportunities, and Gender Status Affect Faculty and Librarians." Presented as a poster session, American Library Association Conference, Dallas, Texas, June 1984.

Displays major findings, with sex as a variable, and also gives a short bibliography.

1984-88 "Semiannual Report on Developments at the Library of Congress. October 1, 1983, Through March 31, 1984." *Library of Congress Information Bulletin* 43 (June 4, 1984): 186-200.

Includes affirmative action information.

1984-89 "Librarian Who Won Tenure Suit Fired by Univ. of Minnesota." *Library Journal* 109 (June 15, 1984): 1166.

Reports firing of Linda Debeau-Melting, one of thirty-seven librarians who filed a sex discrimination suit against the university.

1984-90 Karr, Ronald Dale. "The Changing Profile of University Library Directors, 1966-1981." *College & Research Libraries* 45 (July 1984): 282-286.

Compares characteristics of ARL library directors. Data show an increase in the number of women in administrative positions.

1984-91 Smith, Julie, et al. "Salary Survey of the Medical Library Group of Southern California and Arizona." *Bulletin of the Medical Library Association* 72 (July 1984): 295-300.

Authors' discussion of salary and gender states that respondents' sex affected average salaries by less than one percent.

1984-92 U.S. Department of Education. National Center for Education Statistics. "Three Years of Change in College and University Libraries." *College & Research Libraries News* 45 (July/August 1984): 359.

Academic library statistics from 1979-1982 are reviewed, including data that 75 percent of college and university library staff were women, but only 52 percent of the administrators in 1982 were female (6.9 percent increase since 1979).

1984-93 Berry, John; Nyren, Karl; and Sutten, Judith. "Let the Counterattack Begin." *Library Journal* 109 (August 1984): 1391-1407.

ALA President E. J. Josey's work to "help overcome the pay inequities suffered by women librarians" (p. 1392) is briefly described, as is comparable worth (p. 1392) and the SRRT/COSWL program "The Gender Gap: Women's Political Clout," which featured Elizabeth Kamarch Minnich and Eddie Bernice Johnson.

1984-94 Dwyer, Jim. "Elvira and the Magic Sheepskin." *Technicalities* 4 (August 1984): 1, 4.

Fable of library careers notes sexism as a barrier to Elvira the elf.

1984-95 "Reports on the 75th Annual Conference of the Special Libraries Association, New York City, June 9-14." *Library of Congress Information Bulletin* 43 (August 13, 1984): 264-268.

"Information and Lifestyles" featured Gail Sheehy, who traced the ideas for her two books with reference to librarianship as a profession dominated by women.

1984-96 "Continuing Reports on the 75th Annual Conference of the Special Libraries Assocation." *Library of Congress Information Bulletin* 43 (August 20, 1984): 272-276.

"Government Relations Committee Report" by Lynne McCay and Suzy Platt highlights panel discussion on the legislative scene. Panelists included Lesley Primmer, legislative assistant to Representative Olympia Snowe, and Judy Schneider, specialist in American National Government Division, Congressional Research Service (CRS). Primmer, calling pay equity "the civil rights issue of the eighties," noted that *comparable worth* has become an unfavorable, value-laden term. *Pay equity* is neutral, but *sex-based wage discrimination* most accurately describes the issue.

"Report of the Women's Caucus" by Lynne Kennedy summarizes program titled "Political Savvy in Administration: From a Woman Administrator's Point of View; From a Man Administrator's Point of View" and presented by Ann Talcott, head librarian with Bell Telephone Laboratories, and Ted Slate, head librarian at *Newsweek*.

1984-97 "Bibliography on Women in Librarianship Continued." *On Campus with Women* 14 (Fall 1984): 10.

Announces publication of *On Account of Sex*. [1984-08].

1984-98 "Comparable Worth: Two Librarians Testify." *Wyoming Library Roundup* 40 (Fall 1984): 21-24.

Helen Higby and Lesley Broughton testify in Wyoming in favor of comparable worth.

1984-99 Craver, Kathleen W. "Book Reviewers: An Empirical Portrait." *School Library Media Quarterly* 12 (Fall 1984): 383-409.

Profile of book reviewers includes sex as a variable, both for authors and for reviewers.

1984-100 McDermott, Judy C. "Professional Status of Librarians: A Realistic and Unpopular Analysis." *Journal of Library Administration* 5 (Fall 1984): 17-21.

Cites the predominantly female composition of librarianship as a problem in defining it as a profession. Suggests that improved status of librarians could be achieved through joining with labor unions and feminist organizations to work on pay equity and comparable-worth issues.

1984-101 Rockman, Irene. "Job Satisfaction Among Faculty and Librarians: A Study in Gender, Autonomy, and Decision-making Opportunities." *Journal of Library Administration* 5 (Fall 1984): 43-56.

Reports results of a survey of 220 California State University system faculty and librarians. Respondents were divided into majority (male faculty and female librarians) and minority (female faculty and male librarians) populations. Concludes that "traditionally oriented males" have the highest job satisfaction and that, while gender alone does not predict satisfaction, it does work in combination with autonomy, rank, and experience. [Poster session 1984-87]

1984-102 Phenix, Katharine. "New COSWL Award Promotes Sexual Equality." *American Libraries* 15 (September 1984): 600.

Announces the ALA Equality Award, which is designed to recognize and reward people who have worked toward equality in librarianship.

1984-103 Wedgeworth, Robert. "ALA and the Merwine Case: A Word As to the Whys." *American Libraries* 15 (September 1984): 561-562.

ALA did not testify in the Merwine case because it "presented a potential conflict between two policies about which the Association feels strongly."

1984-104 Wilson, Pauline. "ALA, the MLS, and Professional Employment: An Observer's Field Guide to the Issues." *American Libraries* 15 (September 1984): 563-566.

Discusses the Merwine case, ALA's stance, and the role of ALA membership in influencing the association's role in these types of cases.

1984-105 "First Comparable Worth Salaries in Los Gatos, Calif., Contract." *Library Journal* 109 (September 15, 1984): 1714.

Library workers attain salary adjustments ranging from 4 to 20 percent.

1984-106 Pritchard, Sarah. "Concluding Reports on the Annual Conference of the American Library Association, Dallas, Texas, June 23-27, 1984." *Library of Congress Information Bulletin* 43 (September 24, 1984): 315-319.

Describes the women's groups' introductory session, the program "The Gender Gap: Women's Political Clout" presented by the Feminist Task Force, and a program called "Women Online" sponsored by the RASD Women's Materials and Women Library Users' Discussion Group.

1984-107 "ALA Report Sees Male-Female Salary Discrepancy, Discrimination Against Women as Library Administrators." *Media Report to Women* 12 (September/October 1984): 6.

Contains excerpts from *Career Profiles and Sex Discrimination in the Library Profession* by Kathleen M. Heim and Leigh S. Estabrook [1983-10].

1984-108 DeWeese, June. "Women in Libraries Committee." *Missouri Library Association Newsletter* 15 (October 1984): 14.

Annual report describes meetings of the Women in Libraries Committee of the Missouri Library Association. The group reports working toward having voting status in the association. The film *Accomplished Women* and a presentation by Anne Kenney on women's history research are the other activities mentioned.

1984-109 Shank, Katherine. "Working Less and Enjoying It More: Alternative Work Schedules." *Wilson Library Bulletin* 59 (October 1984): 106-108.

Describes the advantages of flextime, part-time, and job-sharing, particularly as these benefit women in libraries.

1984-110 Van House, Nancy A. "Projections of the Supply of Librarians." *Library Quarterly* 54 (October 1984): 368-396.

Uses the economic theory of occupational choice to predict supply of librarians through the 1900s and projects salaries based on library expenditures, past graduates, and professional women's salaries.

1984-111 "Women's Resources and Concerns Section Established by the Social Sciences Division." *Specialist* 7 (October 1984): 1.

Announces formation of this Special Libraries Association section to discuss women's resources, materials, and issues in special librarianship.

1984-112 Berry, John. "The Value of 'Women's Work.'" *Library Journal* 109 (October 1, 1984): 1784.

Strong statement in favor of comparable worth for librarians.

Letters:

Bender, David R. "SLA: A Decade for Comparable Worth." *Library Journal* 109 (December 1984): 2181. Describes SLA brochure "Equal Pay for Equal Work: Women in Special Libraries" [1976-04] and its revised version [1981-16a], noting that SLA has supported the concept of comparable worth for a long time.

Sauer, James L. "Robber Librarians." *Library Journal* 109 (December 1984): 2181-2182. Disgruntled reply to editorial contains several arguments against what he calls "comparative worth," including the "voting with the pocketbook" argument, the marketplace analogy, and the fallacy of the sixty-two-cents-per-dollar statistic.

Massman, Virgil. "Consider Garbage Workers." *Library Journal* 110 (January 1985): 6. Questions blanket statements about earnings differentials.

Baldwin, Jerome C. "A Question of Gender." *Library Journal* 110 (March 1, 1985): 6. Suggests that job comparisons be made between librarians and engineers rather than between librarians and garbage workers. Author claims not to understand some of Massman's points.

1984-113 Learmont, Carol L., and Van Houten, Stephen. "Placement and Salaries 1983: Catching Up." *Library Journal* 109 (October 1, 1984): 1805-1811.

This 33d annual report on placement and salaries records women's mean salary as $17,563 and men's as $18,303. Results display an 8 percent increase for women and 4 percent for men.

1984-114 Koenig, Michael E. D., and Safford, Herbert D. "Myths, Misconceptions, and Management." *Library Journal* 109 (October 15, 1984): 1897-1902.

Discusses vertical stratification of library structures as the cause of poor horizontal mobility into management positions rather than the racial or sex discrimination normally cited as the cause.

1984-115 "COSWL Bibliography Available." *Channel DLS* (Wisconsin Division of Library Services) 20 (November 1984): 14.

News item announces publication of the Women in Librarianship 1983 bibliography by the ALA Committee on the Status of Women in Librarianship.

1984-116 "Women's Program Advisory Committee Celebrates 10th Anniversary." *Library of Congress Information Bulletin* 43 (November 5, 1984): n.p.

Announces anniversary of this Library of Congress Committee and highlights activities of the year in celebration of the anniversary.

1984-117 Campbell, Ann Morgan. "Child Care Resolution." *American Archivist* 47 (Winter 1984): 88-89.

Describes resolution on child care at conferences presented by Susan Davis for the SAA Women's Caucus.

1984-118 "ALA Midwinter Preview." *Library Journal* 109 (December 1984): 2235.

Announces speaker Winn Newman on "Pay Equity and the Public Good" and formation of the ALA Commission on Pay Equity.

1984-119 "Librarian's Pension Suit Forces Unisex Changes at TIAA-CREF." *American Libraries* 15 (December 1984): 758-761.

News item reports Supreme Court decision not to review a U.S. Court of Appeals ruling ordering that men and women should receive equal retirement benefits. The suit was initiated by Diana Spirt, Long Island University library school professor.

1984-120 "Semiannual Report on Developments at the Library of Congress from April 1, 1984, Through September 30, 1984." *Library of Congress Information Bulletin* 43 (December 24, 1984): 420-440.

Equal employment opportunity, affirmative action, and the Women's Executive Leadership programs are described.

1985-01 American Library Association. Committee on the Status of Women in Librarianship. *Women Librarians Re-Entering the Work Force*. Chicago: American Library Assn., 1985.

Results of a research project on reentry women funded by an ALA Goal Award in 1982.

1985-02 Antolin, Laura Kathryn Dranoff. "Women in Management: A Review of the Literature of Librarianship and Social Work, 1970-1980." Master's thesis, University of Chicago, 1985.

The history, theories, legislation, and impact of the women's movement on women in the labor force are reviewed, as is the literature on women in management in librarianship and social work. A comparison of the two occupations finds inequity of salaries, lack of representation in administration, and occupational segregation in both. Author concludes that although the women's movement has raised the consciousness of members of both occupations, it has done little in regard to affecting the economic situation or the status of women in these occupations.

1985-03 Crane, Jane L. *Salary Comparisons of 1979-80 College Graduates, by Sex, in May 1981*. Washington, D.C.: Govt. Print. Off., 1985. (NCES) (ED 102: Sa3) (4828-20 ASI 1985)

Data based on a 1981 survey of bachelor's and master's degree recipients are represented in tables that show estimated number and mean salaries of male and female 1979–1980 graduates by industry and occupational group.

1985-04 Etaugh, Claire. *Changes in the Status of Women Faculty and Administrators in Higher Education Since 1972*. Bethesda, Md.: ERIC Document Reproduction Service, 1985. (ED 254 181)

Uses the field of library science as an example of a stereotypically feminine discipline in higher education. The report itself considers discipline and type of institution, salary rank and tenure of women faculty, and employment patterns and salary of women administrators. Half of all women administrators in white, coeducational institutions are concentrated in ten positions, one of which is library director.

1985-05 Fenster, Valmai Kirkham. *Out of the Stacks: Notable Wisconsin Women Librarians*. Madison, Wis.: Wisconsin Women Library Workers, 1985.

This collection of biographies of women librarians is included here because it represents work done by Fenster in the pages of the Wisconson Women Library Workers' *Newsletter*, a feminist librarians' forum, just before her death.

1985-06 Hamshari, Omar Ahmad Mohammad. "Job Satisfaction of Professional Librarians: A Comparative Study of Technical and Public Service Departments in Academic Libraries in Jordan." Ph.D. thesis, University of Michigan, 1985.

Sex is used as a variable in this study of job satisfaction.

1985-07 Heim, Kathleen M. "Determinants of Gender Stratification in the Library Profession." In *Nos ressources humaines: La clé d'un bon service/ Personnel: Key to Successful Public Service*. Edited by Réjean Savard. Montreal, Québec: Corporation des bibliothécaires professionels du Québec, 1985.

Printed version of a presentation on the history and status of women in librarianship. Concisely states that much of what contributes to gender inequality is societal, and "until external authorities are able to evaluate the credentials of men and women on the same basis, . . . we are going to have difficulty in seeing women achieve administrative parity" (p. 40).

1985-08 Henderson, Carolyn J. "Personnel and Employment: Recruitment and Selection." In *ALA Yearbook of Library and Information Services '85*. Edited by Robert Wedgeworth. Chicago: American Library Assn., 1985: 213-214.

Summarizes the issue of comparable worth and the Merwine case.

1985-09 Irvine, Betty Jo. *Sex Segregation in Librarianship: Demographic and Career Patterns of Academic Library Administrators*. Westport, Conn.: Greenwood, 1985.

Documents the change in sex ratios since affirmative action implementation in 1972. Basing her conclusions on demographic and career data collected from a survey of ARL administrators, Irvine shows that women have increased in representation as administrators, but that the field is still male intensive. She also looks at mobility and career history, role models and mentors, and professional affiliations and activities.

Reviews:

Blake, Fay M. "Another Demographic Study." *Library Journal* 110 (September 1, 1985): 148.

Borck, Helga. *Special Libraries* 76 (Fall 1985): 297-298.

Brooks, Richard, and Dickinson, Luren. *National Librarian* 11 (May 1986): 3-4.

Creth, Sheila. *Journal of Academic Librarianship* 12 (March 1986): 34.

Miller, Constance. *College & Research Libraries* 47 (March 1986): 186-188.

Moran, Barbara B. *Journal of Education for Library and Information Science* 26 (Winter 1986): 202-204.

Robinson, Judith. *The Library Quarterly* 56 (April 1986): 191-192.

Stevens, Norman. "Our Profession." *Wilson Library Bulletin* 60 (October 1985): 59.

1985-10 Johnson, Richard D. "Academic Librarians." In *ALA Yearbook of Library and Information Services '85*. Edited by Robert Wedgeworth. Chicago: American Library Assn., 1985: 26-33.

Notes University of Minnesota settlement on behalf of thirty-seven women librarians (p. 32).

1985-11 Ladenson, Alex. "Law and Legislation." In *ALA Yearbook of Library and Information Services '85*. Edited by Robert Wedgeworth. Chicago: American Library Assn., 1985: 167-168.

Merwine case is described.

1985-12 Learmont, Carol L., and Van Houten, Stephen. "Placement and Salaries 1983: Catching Up." In *Bowker Annual*. 30th ed. New York: Bowker, 1985: 357-371.

Thirty-third annual report on placement and salaries of graduates of ALA-accredited library education programs shows that the 1983 average (mean) beginning salary for women was $17,563, an 8 percent increase over 1982; and for men, $18,303, a 4 percent increase. Adaptation of [1984-113].

1985-13 Phenix, Katharine. "Women in Librarianship." In *ALA Yearbook of Library and Information Services '85*. Edited by Robert Wedgeworth. Chicago: American Library Assn., 1985: 292-296.

Summary of published material on women in libraries, salary surveys with data on gender, and activities of groups that focused on the status of women in libraries.

1985-14A Purcell, Gary R. "Faculty." In *Library and Information Science Education Statistical Report 1985*. State College, Pa.: Assn. for Library and Information Science Education, 1985: F1-F89.

Twelfth survey of faculty information pertaining to library education includes tables showing male-female ratio among full-time faculty, average salaries broken out by sex, and rank and sex of new faculty. Also compares female and male faculty salaries; gives percentages of full-time faculty with earned doctorates, divided by sex; and gives tenure status by rank and sex.

1985-14B Sparks, Glenn. "Students." In *Library and Information Science Education Statistical Report 1985*. State College, Pa.: Assn. for Library and Information Science Education, 1985: S1-S67.

Includes information on enrollment by program and sex based on official enrollment in the fall 1984 term; and gives profile of the student body by program levels, including number of students by sex and ethnic origin and number of students by age and sex. Also includes data on scholarships and assistantships awarded to students officially enrolled in 1983-1984, by amount, sex, and program level. Master's degree students enrolled full time in the fall 1984 term totaled 791 men and 2,498 women at the sixty-six schools reporting. At the doctoral level there were seventy-three men and 101 women in the twenty-four schools reporting.

1985-15 Query, Lance. "Personnel and Employment: Compensation." In *ALA Yearbook of Library and Information Services '85*. Edited by Robert Wedgeworth. Chicago: American Library Assn., 1985: 211-213.

"Pay Parity" section mentions comparable-worth action.

1985-16 Schlachter, Gail A. "Abstracts of Library Science Dissertations." In *Library Science Annual*, vol. 1. Edited by Bohdan S. Wynar. Littleton, Colo.: Libraries Unlimited, 1985: 181-192.

Introduction notes that although women constituted the majority of practicing librarians, they authored a minority of library science dissertations from 1925 to 1979. In 1980 and 1981 women were responsible for more than 50 percent of dissertations, but in 1983 the percentage dropped to 45 percent.

1985-17 Sellen, Betty Carol, and Vaughn, Susan J. "Alternative Careers for Librarians." In *Bowker Annual*. 30th ed. New York: Bowker, 1985: 331-337.

Summarizes results of survey on the movement of librarians from traditional library jobs into the area of information services, published in *New Options for Librarians: Finding a Job in a Related Field* (Neal-Schuman, 1984). Female respondents totaled 76.8 percent. Adaptation of [1984-25].

1985-18 Storey, R. A. "Prospect and Prejudice, or Women in Librarianship 1880-1914; a Fourth Footnote." *Library History* 7 (1985): 21-22.

In response to Munford's article on Mary Petherbridge [1984-16], the author

provides the text of Petherbridge's section on indexing found in the *English-woman's Year Book and Directory* of 1914, in which she notes that "the qualities required (in an indexer) are common sense, an infinite capacity for taking pains, conscientiousness, mental mobility, and stability, all of which qualities are constantly to be found in women."

1985-19 U.S. Department of Education. National Center for Education Statistics. *The Condition of Education, 1985.* Washington, D.C.: Govt. Print. Off., 1985.

Relevant statistical information here consists of data collected annually on higher education enrollment, specifically Table 2.20, "Percent of Earned Degrees Awarded to Females by Institutions of Higher Education by Level of Degree and Discipline Division."

1985-20 U.S. Department of Labor. Women's Bureau. *United Nations Decade for Women, 1976-1985: Employment in the U.S.* Washington, D.C.: Govt. Print. Off., 1985.

Tabular data includes library fields.

1985-21 U.S. Library of Congress. *Librarian of Congress Annual Report 1984.* Washington, D.C.: Govt. Print. Off., 1985. (LC1.1: 984)

Reports on activities of the Equal Employment Opportunity programs and the Women's Program office.

1985-22 Anderson, Dorothy J. "Comparative Career Profiles of Academic Librarians: Are Leaders Different?" *Journal of Academic Librarianship* 10 (January 1985): 326-332.

Comparison of career characteristics of twenty-five Council on Library Resources (CLR) Senior Fellows with those of ACRL members reveals that "leaders" in academic librarianship scored higher on all three variables tested: visibility, mobility and responsibility. Study contradicts Moran's finding [1982-27] that there is no relationship between variables such as higher degrees, more publications, association activity, and career advancement for women.

1985-23 Brandehoff, Susan. "Spotlight on Women Managers." *American Libraries* 16 (January 1985): 20-28, 45-46.

Interviews focus on differences in management styles between women and men. Those interviewed are Linda Beaupre, Mary F. Lenox, Elizabeth K. Gay, Bridget L. Lamont, Sharon J. Rogers, and Judy K. Rule. Other career influences, such as networking, mentors, and education, are discussed.

1985-24 Chandler, G. "Editorial Commentary." *International Library Review* 17 (January 1985): 1-4.

Introduces Maack's article [1985-26] by noting that it includes a list of notable theoretical studies that Maack points out have failed to encourage the

production of specific comparative studies of the feminization of other professions.

1985-25 Gerhardt, Lillian N. "Feminist Activist Librarian of the Year." *School Library Journal* 31 (January 1985): 2.

Editorial salutes Diana Spirt, professor at the Palmer School of Library and Information Science, Long Island University, who led and won a class-action suit against the Teachers' Insurance and Annuity Association-College Retirement Equities Fund (TIAA-CREF) for sex discrimination in pension benefits.

1985-26 Maack, Mary Niles. "Comparative Methodology as a Means for Assessing the Impact of Feminization and Professionalization of Librarianship." *International Library Review* 17 (January 1985): 5-16.

Compares the status of women and the status of librarianship in the United States, Great Britain, and France. A comparative chronology reveals, for instance, that it took ninety years for British librarians to elect a woman president, as opposed to the French and the Americans, who did it within twenty-five and thirty-five years, respectively.

1985-27 Mellor, Earl F. "Weekly Earnings in 1983: A Look at More than 200 Occupations." *Monthly Labor Review* 108 (January 1985): 54-59.

Table 1 shows weekly earnings in occupational groupings by sex and the ratio of female/male earnings for librarians, archivists, and curators.

1985-28 Merrill, Martha. "Truth in Advertising—Not for Librarians." *Show Me Libraries* 36 (January 1985): 26-27.

Notes that recent television commercials describe librarians as "60+ female, tall and emaciated, hair in a bun, wearing glasses, and continuously making shushing noises" and concludes that the mass media is distorting the reality of the profession and by doing so is affecting children's perception of librarianship as an occupation and future career choice. Reprinted from *Southeastern Libraries* (Spring 1984).

1985-29 Moore, Nick, and Kempson, Elaine. "The Size and Structure of the Library and Information Workforce in the United Kingdom." *Journal of Librarianship* 17 (January 1985): 1-16.

Analysis of census and employment data from 1972-1981 demonstrates that women no longer leave the work force in the same numbers as in the past and that a significant number of women display the same career patterns as men. As a result, there are larger numbers of working women in older age groups, and such women outnumber men in all age groups.

1985-30 "News in Review, 1984." *Library Journal* 110 (January 1985): 43.

Reports weapon of "comparable worth" used by Cleveland Public Library, Douglas County Library in Roseburg, Oregon, and Minnesota libraries to up-

grade library positions. Also mentions President's Commission on Pay Equity created by ALA's Executive Board.

1985-31 Nyren, Karl. "Affirmative Action Reports: Despite White House Chill, Libraries Maintain Effort." *Library Journal* 110 (January 1985): 14, 16.

Notes that strides are being made despite the "conservative mood of the nation" as exemplified by the Heritage Foundation's recommendations to President Reagan to block comparable-worth activities.

1985-32 Taylor, David. "Ladies of the Club: An Arkansas Story." *Wilson Library Bulletin* 59 (January 1985): 324-327.

Chronicles the development of the town library in Helena, Arkansas, by the Women's Library Association. Profiles women who were instrumental in that library's development.

Letter:

Badkin, Sharon. "Rising Up in Protest." *Wilson Library Bulletin* 59 (April 1985): 517.
Protests author's stereotyping of Southern women.

1985-33 Tierney, Judith, and Mech, Terry. "Directors of Small College Libraries in the Northeast: Who Are They?" *Technicalities* 5 (January 1985): 7-9.

Profiles qualifications, interests, and backgrounds of small college library directors of 148 small Northeastern colleges. Most striking feature of profile is that 55 percent of directors are women; and most notable distinction between men and women is that 53 percent of women were promoted to directorship from within the ranks, whereas only 16.6 percent of men received the position this way.

1985-34 Veaner, Allen B. "Women at the Top: An Interview with Marianne Scott, New Director of the National Library of Canada." *American Libraries* 16 (January 1985): 18-19.

Scott responds to the question of women as managers. She says, "The unique strength of a top administrator lies within that person's individuality; it is not a male or female thing. It is right and proper that more females should enter the ranks of top management, and now that can be done because of changes in society."

1985-35 Wong, William S., and Zubatsky, David S. "The Tenure Rate of University Library Directors: A 1983 Survey." *College & Research Libraries* 46 (January 1985): 69-77.

Of the directors studied, 141 were men and thirty were women. Of the women, twenty-seven had held their positions for ten or fewer years. Authors suggest that "an increase in the mobility of women may cause the average tenure period to decline once again. . . . "

1985-36 Nzotta, Briggs C. "Factors Associated with the Job Satisfaction of Male and Female Librarians in Nigeria." *Library and Information Science Research* 7 (January/March 1985): 75-84.

Even though there are more men than women in Nigerian libraries, librarianship is still considered a woman's profession. The author finds that men tend to be less satisfied with their positions than women, based on the results of the Minnesota Satisfaction Questionnaire (MSQ) and a mailed questionnaire.

1985-37 Van House, Nancy. "The Return on the Investment in Library Education." *Library and Information Science Research* 7 (January/March 1985): 31-52.

By measuring lifetime income of librarians and comparing it with that of nonlibrarians, author finds the MLS degree to be a poor investment. Implications of this finding are that while it was once a relatively good choice for women to go into librarianship, it is no longer. Men move into the profession only if assured of the top positions.

1985-38 "ALA Seeks Pay Equity Reports for Study." *Show Me Libraries* 36 (February 1985): 7.

The ALA Commission on Pay Equity and OLPR request information on library-related pay equity and job evaluation studies. Announcement includes a short definition of *pay equity*, or *comparable worth*.

1985-39 Galloway, Sue. "Comparable Worth Adjustments: Yes." *American Libraries* 16 (February 1985): 92.

Concludes that a significant first step in establishing wage justice for women is to acknowledge the value of traditional female jobs; also contends that encouraging women to forsake traditional female professions and to find better-paying male jobs is sexist and will not correct disparity between male and female wages.

1985-40 Little, Jane. "Women in Libraries." *New Library World* 86 (February 1985): 34.

First bimonthly column on the topic describes book fairs, gay bookstores, materials for blind and physically handicapped women, and the upcoming Women in Libraries conference.

1985-41 "MLS vs. Store Clerk." *American Libraries* 16 (February 1985): 82.

A suit is filed against the East Grand Forks, Minnesota, Public Library upon the hiring of a male store clerk and library board member as library director.

1985-42 O'Neill, June. "Comparable Worth Adjustments: No." *American Libraries* 16 (February 1985): 93-94.

Expresses the viewpoint that comparable-worth regulations would interfere with the market law of supply and demand, would disrupt the economy, and would not be in the best interest of women.

Letters:

Rothchild, Nina. "Comparable Worth Works in Minnesota." *American Libraries* 16

(April 1985): 212-213. Commissioner of the Minnesota Department of Employee Relations writes in favor of pay equity.

Dopp, Bonnie Jo. "Market Forces vs. Force of History." *American Libraries* 16 (April 1985): 212. Provides sources for more information on pay equity to help retire "fears" expressed by O'Neill.

1985-43 "Women and Minorities: Their Proportions Grow in the Professional Work Force." *Monthly Labor Review* 108 (February 1985): 49-50.

Findings from the 1984 annual edition of *Professional Women and Minorities* are noted. Of interest are summaries of findings about employment of women and minorities in higher education.

1985-44 "Pay Equity Ammo Sought by ALA." *Library Journal* 110 (February 1, 1985): 30.

Reports request from the ALA Commission on Pay Equity for job evaluation studies, litigation information, worker classifications, and other materials from libraries and other organizations involved in pay equity issues.

1985-45 "Minnesota Library May Be Sued for Hiring Non-MLS Male." *Library Journal* 110 (February 15, 1985): 100.

A possible suit is reported against the East Grand Forks Public Library by degreed women applicants for a director's post. They were not hired, in favor of a male clothing store clerk who had been on the library board for fifteen years.

1985-46 Gerhardt, Lillian N. "Feminist Activist Librarian of the Year." *Bookwoman* 49 (Spring 1985): 11.

Describes Diana L. Spirt's class-action suit against the Teachers' Insurance and Annuity Association and the College Retirement Equities Fund and notes that the decision in her favor affects many library women.

1985-47 "Facts for Management on the Status of Women in Librarianship." *LAMA Newsletter* 11 (March 1985): 29.

Announces fact sheets developed by the Committee on the Status of Women in Librarianship.

1985-48 Hegg, Judith L. "Continuing Education: A Profile of the Academic Librarian Participant." *Journal of Library Administration* 6 (March 1985): 45-63.

Many demographic variables, including sex, marital status, etc., are examined. Of the seventy-seven women and forty-three men, a higher percentage of women were involved in continuing education. Also of interest is that 18 percent of the women published as opposed to 12 percent of the men.

1985-49 Mech, Terrence. "Small College Library Directors of the Midwest." *Journal of Academic Librarianship* 11 (March 1985): 8-13.

Experience, education, and background of academic library directors in insti-

tutions serving fewer than 3,500 students are variables observed. Of the sample, 45 percent were women, but most women directors were at the smallest colleges. Women were also found to hold fewer degrees and to be older and less career mobile than men.

1985-50 Steiger, Monte L. "Getting into a Scrape Over Slurs." *American Libraries* 16 (March 1985): 152.

Letter from farm-raised librarian suggests that the problem of image and stereotyping of librarians should be ignored, since other occupations suffer from the same kind of broad, erroneous generalizations.

1985-51 "Cadre to Build Coalitions." *Library Journal* 110 (March 15, 1985): 19-22.

Mentions SRRT Feminist Task Force debate at 1985 ALA Midwinter Meeting regarding the need to reconcile intellectual freedom with feminist feelings regarding violence and pornography. Pay equity is a concern as well.

1985-52 "Pay Equity in Berkeley." *Library Journal* 110 (March 15, 1985): 14.

News item reports 9 percent Special Equity Adjustment for the staff of the Berkeley, California, Public Library.

1985-53 "Court of Appeals Finds Against Merwine." *Wilson Library Bulletin* 59 (April 1985): 519.

Reports decision of U.S. Court of Appeals, Fifth Circuit, against Glenda Merwine.

1985-54 Little, Jane. "Women in Libraries." *New Library World* 86 (April 1985): 71.

Breast-feeding facilities and women-oriented collections in public libraries are noted, as well as information on the International Feminist Book Fair.

1985-55 Moore, Nick, and Kempson, Elaine. "The Nature of the Library and Information Workforce in the United Kingdom." *Journal of Librarianship* 17 (April 1985): 137-154.

Summarizes findings of several surveys in the areas of job satisfaction, nature of duties, value of educational qualifications, mobility and wastage, choice of career, and the position of women. Results conclude that there is still substantial discrimination against women reflected in salary, status, and seniority.

1985-56 Churchman, Deborah. "Library Professionals: Fighting for Comparable Pay." *Christian Science Monitor*. April 16, 1985: 33-34.

Feminist librarians Kathleen Heim, Michele Leber, Margaret Myers, and others are quoted in a discussion of the issues associated with comparable worth and women in librarianship.

1985-57 Melber, Barbara D., and McLaughlin, Steven D. "Evaluation of a Career Development and Assessment Center Program for Professional Librari-

ans." *Library and Information Research* 7 (April-June 1985): 159-181.

Authors conclude, "To the extent the program both sensitizes managerial level librarians to the issue of women's status in the profession and improves observational skills and behavior-based evaluation of performance, career advancement of women librarians may be enhanced through changes in the assessors' approach to hiring and promotion at their places of work."

1985-58 Biggs, Mary. "Replacing the Fast Fact Drop-in with Gourmet Information Service." *Journal of Academic Librarianship* 11 (May 1985): 68-78.

Asks the question "Has the sex of our majority helped shape our service assumptions?" since "women are socialized to sacrifice self . . . " (p. 69).

1985-59 Kerns, Ruth. "Our Woman in America." *New Library World* 86 (May 1985): 89-90.

Regular columnist comments on comparable-worth struggles in the United States.

1985-60 Phenix, Katharine. "Women Librarians Re-Entering the Workforce: A Summary Report." *American Libraries* 16 (May 1985): 302-303.

Summarizes data obtained in [1985-01], compiled by Katherine Murphy Dickson for the Committee on the Status of Women in Librarianship.

Letters:

Nisenhoff, Sylvia. "Rough Road to Re-entry." *American Libraries* 16 (July/August 1985): 468. Describes anger and anguish of attempt to reenter library profession after seventeen years of homemaking.

Myers, Margaret. "Re-entry Report Righted." *American Libraries* 16 (September 1985): 543. Points out that project surveyed women librarians who had been out of profession from two to ten years, not two to five years as stated in the article.

1985-61 "Northwest Library Unions Discuss Pay Equity, Technology." *Library Journal* 110 (May 1, 1985): 21.

Pay equity is among the topics of discussion at a three-day workshop on library unions in Washington State.

1985-62 "ALA Fact Sheets on Status of Women in Librarianship." *Texas Library Journal* 61 (Summer 1985): 31.

Announces availability of fact sheets on topics such as pay equity, nondiscrimination in insurance, and child care that were developed by the ALA Committee on the Status of Women in Librarianship.

1985-63 Dewey, Barbara I. "Selection of Librarianship as a Career: Implications for Recruitment." *Journal of Education for Library and Information Science* 26 (Summer 1985): 16-24.

Reports results of a questionnaire given to students over a three-year period at Indiana University School of Library and Information Science. Review of the literature on occupation choice cites many studies on the impact of sex-role

stereotyping and sex structuring of occupations on women's choice of librarian-ship as a career.

1985-64 "Member Profile: Carol Neymeyer." *Bookwoman* 49 (Summer 1985): 8-9.
 Describes Nemeyer as a role model for women in librarianship.

1985-65 "Parenting and Librarianship: A Balancing Act." *PNLA Quarterly* 49 (Summer 1985): 49.
 Describes balancing act required to juggle library jobs to maintain career ties and skills while rearing a young family.

1985-66 Jayawardene, Marion. "Libraries and Women." *New Library World* 86 (June 1985): 108-110.
 Discusses barriers to women's equality in librarianship, such as interrupted careers, sexism, and lack of flexible hours. Some statistics on British library personnel composition are provided.

1985-67 Little, Jane. "Women in Libraries." *New Library World* 86 (June 1985): 112.
 Examines stereotyped reasons why women fail to land top management jobs in libraries and mentions "nagging feeling" that interviewers were really look-ing for a man.
 Letters:
 Walker, Martin. "Women and Job Interviews." *New Library World* 86 (September 1985): 166. Takes issue with points in Little article and feels that Little uses excuses of racism and sexism for failure of women to obtain top management positions.
 Mason, Chris. "Women and Job Interviews." *New Library World* 86 (September 1985): 166. Takes issue with several of Little's points and concludes that it is up to interviewee to guide interviewers and "show them the error of their thoughtless ways."

1985-68 "Los Angeles Librarians Win Pay Equity Victory." *American Librar-ies* 16 (June 1985): 368-370.
 Notes that new contract gives special raises to 326 librarians, mostly women, to bring their salaries up to the level of employees in male-dominated profes-sions.

1985-69 Pearson, Lois R. "Executive Director Search and Selection Process Detailed." *American Libraries* 16 (June 1985): 366-368.
 Describes search process, includes gender of applicants, and outlines feminist protests against hiring a man for the position. Partial text of the letter from the Committee on the Status of Women in Librarianship to the Executive Board is printed here. It reads, "The statement we make by hiring a white man as the top administrator of a profession which is predominantly women is not that there are

not women qualified to lead us, but that we do not yet know how to find them, nurture them, and encourage them to come forward and lend us their strength."

1985-70 Plotnik, Art. "Life in a Glass House." *American Libraries* 16 (June 1985): 364.

Editorial notes that affirmative action notwithstanding, a man was hired as ALA Executive Director. Perhaps he was the best person for the job.

1985-71 Watstein, Sarah Barbara. "ALA Search Process Questioned." *American Libraries* 16 (June 1985): 378.

Letter questions search process for ALA Executive Director.

1985-72 "Comparable Worth at LAPL." *Library Journal* 110 (June 15, 1985): 11.

Librarians at the Los Angeles Public Library (LAPL) receive comparable-worth salary adjustments.

1985-73 Baird, Lynn. "Comparable Worth." *Idaho Librarian* 37 (July 1985): 65.

Describes concept of comparable worth and provides a brief annotated bibliography.

1985-74 Schmidt, Karen R. "'Deucedly Independent': A Biographical Overview of the Library Career of Eleanor Weir Welch." *Library Quarterly* 55 (July 1985): 300-315.

To broaden the study of women librarians in history, Schmidt examines the career of Welch as an example of a "little known figure" in librarianship who did not fit the traditional role of women of her time, 1917-1959.

1985-75 "Women in Librarianship: Bibliography 1984." *Specialist* 8 (July 1985): 4.

Announces 1984 list of articles on women in libraries compiled by Katharine Phenix and available through the ALA Committee on the Status of Women in Librarianship.

1985-76 "Semiannual Report on Developments at the Library of Congress, October 1, 1984, through March 31, 1985." *Library of Congress Information Bulletin* 44 (July 1, 1985): 151-172.

Status of the Administrative Detail Program, which was designed to encourage minorities and women, is discussed; also Women's Program Advisory Committee activities are mentioned.

1985-77 Fiscella, Joan, and Goodyear, Mary Lou. "Pursuing the Elusive Salary Range." *American Libraries* 16 (July/August 1985): 503-504.

Outlines advantages of publishing salary ranges in ads for library jobs and describes ALA Policy 54.18 concerning this practice. Also notes 1982 COSWL

survey to monitor Policy 54.18, showing that 85 percent of all ads included some type of salary information, but only 33 percent listed ranges.

1985-78 "Los Angeles Settles Pay Equity Problem." *School Library Journal* 31 (August 1985): 31.
Announces pay equity adjustments amounting to $36 million for city employees, including librarians, in Los Angeles.

1985-79A "The Very Thing for Ladies." *Library Association Record* 87 (August 1985): whole issue.
Cover title of special issue on women in librarianship in Great Britain.

1985-79B "Monstrous Regiment." *Library Association Record* 87 (August 1985): 285.
Introduction to the special issue states that the issue makes a "serious attempt to look at the position of women in a field where over 70 percent of the practitioners, yet only about 13 percent of the managers, are women."

1985-79C "Women in Libraries: Two Courses." *Library Association Record* 87 (August 1985): 287.
"Moving into Management" and "Divided Loyalties: The Work/Home Balancing Act" are two workshops available for women librarians.

1985-79D Kempson, Elaine. "Position of Women in the Library and Information Workforce." *Library Association Record* 87 (August 1985): 290-291, 293.
Abstracted information from [1985-29] and [1985-55].

1985-79E Ray, Sheila, and Rodger, Elizabeth M. "It Never Occurred to Me That I Couldn't Get to the Top." *Library Association Record* 87 (August 1985): 293-294.
Ray's career as a library manager, library association councillor, and library school educator is described. Sees a positive future for women in libraries. Rodger, librarian at the University of Sussex, notes, "I did not set out . . . to reach the top of the tree, it all just happened."

1985-79F Roaf, Margery, and Robinson, Mary. "Women Librarians in the Male-Dominated World of Engineering." *Library Association Record* 87 (August 1985): 294.
Each author describes her career experiences.

1985-79G Redfern, Margaret. "Learning to Stop the Everyday Collusion." *Library Association Record* 87 (August 1985): 294.
Personal description of attitudes encountered by women librarians.

1985-79H Plaister, Jean M., and Casteleyn, Mary. "Perhaps I Have Been Lucky . . . " *Library Association Record* 87 (August 1985): 295.
Comments from successful women librarians who attribute their positions to hard work, family support, and luck.

1985-79I Raddon, Rosemary; Pantry, Sheila; and Steward, Jean. "Expanding Educational Role." *Library Association Record* 87 (August 1985): 295, 297.

Descriptions of career paths and suggestions about developing new attitudes toward jobs.

1985-79J Abell, Angela, and Crabtree, Judith. "Women in Industry." *Library Association Record* 87 (August 1985): 297.

Comments on women in a man's professional world.

1985-79K Dunphy, Elaine M. "Choices, Compromises, and Risk." *Library Association Record* 87 (August 1985): 298.

Suggests that assessment and planning are helpful for women's career paths and cautions against making too much of problems facing women librarians.

1985-79L "Conversations." *Library Association Record* 87 (August 1985): 298.

Editorial comments and opinions of Gilly Haines, who is not a women's libber but . . .

1985-79M "No Prejudice." *Library Association Record* 87 (August 1985): 298.

Interviews with Christine Wares and Rosa Chan, who state that they have not encountered prejudice in their jobs.

1985-79N Jayawardene, Marion. "Women in Libraries." *Library Association Record* 87 (August 1985): 299.

History of the five-year-old women's group Women in Libraries, its newsletter *WILPower*, and its goals, objectives, and accomplishments.

1985-79O Horsnell, Verina. "Bits and Pieces." *Library Association Record* 87 (August 1985): 301.

Under the heading "Women, Libraries and IT," it is noted that schoolgirls who attended a technical conference had never considered librarianship as a career and did not know what "information technology" was.

Letters:

Little, Jane. "Women in Libraries." *New Library World* 86 (October 1985): 192-193. This critical review of the *Library Association Record*'s August issue [1985-79A] on women suggests a more radical feminist approach.

Brittin, Margaret, et al. "The Reasons Why Women Stay Behind." *Library Association Record* 87 (November 1985): 475. Criticizes lack of consideration for the reasons why women remain unequal and points out the lack of positive suggestions to improve this position.

Hodgson, N.B. "No Solidarity." *Library Association Record* 88 (January 1986): 12. Suggests that women themselves have contributed to barriers against improving their position in libraries.

1985-80A DuMont, Rosemary Ruhig. "Introduction." (Women and Leadership in the Library Profession) *Library Trends* 34 (Fall 1985): 163-167.

Editor notes that ten articles compose the issue, providing multi-varied approaches to the past, present, and future of women in libraries and leadership positions.

1985-80B Phenix, Katharine. "Sex as a Variable: A Bibliography of Women in Libraries 1975-1985." *Library Trends* 34 (Fall 1985): 169-183.

Substantive research on women in libraries is identified and categorized by subject. General sources of published survey data on librarians, broken out by sex, are also described.

1985-80C Hildenbrand, Suzanne. "Ambiguous Authority and Aborted Ambition: Gender, Professionalism, and the Rise and Fall of the Welfare State." *Library Trends* 34 (Fall 1985): 185-198.

In a review of the traditional approaches to the history of women in librarianship, Hildenbrand formulates the question, "Is it not possible that the structure of society and the field—and not women themselves—prevents female achievement in the profession?" The author points to Dewey's early rise in the library ranks while a group of bright, energetic young women (the Wellesley half-dozen) stayed behind in lower positions as a typical career pattern.

1985-80D Moran, Barbara B. "The Impact of Affirmative Action on Academic Libraries." *Library Trends* 34 (Fall 1985): 199-217.

Describes the purpose, methodology, and results of a study conducted in 1982 to assess the impact of equal opportunity and/or affirmative action law on academic libraries. Data were collected from ARL member libraries, research and doctoral-granting university libraries, and liberal arts college libraries. Study findings showed a slight improvement in the status of women, but women were still seriously underrepresented at the director's level.

1985-80E Swisher, Robert; DuMont, Rosemary Ruhig; and Boyer, Calvin. "The Motivation to Manage: A Study of Academic Librarians and Library Science Students." *Library Trends* 34 (Fall 1985): 219-234.

Findings of a study conducted by administering the Miner Sentence Completion Scale to male and female academic librarians and MLS students reveal that motivation to manage is not a factor that differentiates males from females in the rise to administrative library positions.

1985-80F Irvine, Betty Jo. "Differences by Sex: Academic Library Administrators." *Library Trends* 34 (Fall 1986) 235-257.

This thorough investigation of the characteristics of academic library administrators (family background, mobility and career history, role models and mentors, professional activities) reveals an upward trend for women. Concludes that

women may have to make trade-offs in career vs. family, which men do not face. Based on book [1985-09].

1985-80G Greiner, Joy M. "A Comparative Study of the Career Development Patterns of Male and Female Library Administrators in Large Public Libraries." *Library Trends* 34 (Fall 1985): 259-289.

Directors of public libraries that serve populations of over 100,000 were targeted for the study. Responses were returned from 189 males and 132 females. Some significant differences in career patterns were demonstrated. The questionnaire and a discussion of comments are included.

1985-80H Ivy, Barbara. "Identity, Power, and Hiring in a Feminized Profession." *Library Trends* 34 (Fall 1985): 291-308.

Discussion of findings in a 1984 survey [1984-11] urges women in libraries to take positive action toward climbing the career ladder. Says that power, as a measurable attribute, may be a key to females' obtaining top administrative positions.

1985-80I Moriearty, Jill, and Robbins-Carter, Jane. "Role Models in Library Education: Effects on Women's Careers." *Library Trends* 34 (Fall 1985): 323-341.

Students at the University of Wisconsin-Madison School of Library and Information Science were surveyed in 1985 in order to gather information about the influence of role models and role model gender in the career choices of "near" professionals. The possibility that gender often appears as an important variable in career choice and its impact on sex-role stereotyping are discussed.

1985-81 "ALA Elected to Pay Equity Board." *Wilson Library Bulletin* 60 (September 1985): 18.

Notes that Committee on the Status of Women member Michele Leber is the representative.

1985-82 Rentschler, Cathy. "WNBA Breakfast at ALA Features Update on Women's Groups." *Bookwoman* 49 (Fall/Winter 1985): 13-14.

Speakers included Katharine Phenix, Judith Gallagher, Kathleen Ketterman, and Sandra K. Paul, who represented groups of women in libraries and publishing.

1985-83 Rogers, Sharon. "Academics Abroad: U.S. Librarians Visit the People's Republic of China." *College & Research Libraries News* 46 (September 1985): 399-403.

Barbara Ford (p.400) and Vivian Peterson (p. 402) note the absence of women in higher administrative positions in China.

1985-84 Van House, Nancy. "MLS Delivers Poor Payoff on Investment." *American Libraries* 16 (September 1985): 548-551.

Study to determine value of MLS degree assumes MLS graduate earned average starting salary, received regular pay increases, and retired at age sixty-five. Such graduates are compared with average bachelor's degree-holders of the same sex under the same assumptions. Findings conclude, "Librarians never make back the costs of their degrees," and the MLS is an even worse investment for men than women, because men with bachelor's degrees earn more than women with bachelor's degrees. Author suggests consideration of two solutions: increasing salaries or reducing costs of library education.

Response:

Hildenbrand, Suzanne. "MLS Degree a Money-Loser? Don't Believe It." *American Libraries* 16 (November 1985): 735. A response to Van House article concludes that Van House errs when she compares earning potential of library students to that of the entire pool of bachelor's degree-holders. Also takes issue with Van House's premise that men sustain a greater loss than women by attending library school.

Letter:

Van House, Nancy. "The MLS's Payoff: Round Three." *American Libraries* 16 (December 1985): 762. Defends data used and conclusions drawn in article on the MLS and its payoff in earnings.

1985-85 "ALA Moves Up in the Councils of Comparable Worth." *Library Journal* 110 (September 15, 1985): 18.

Michele Leber is ALA's representative to the National Committee on Pay Equity.

1985-86 "Comparable Worth Laid Low by Equal Opportunity Agencies." *Library Journal* 110 (September 15, 1985): 28.

Reports Equal Employment Opportunity Commission ruling against assistance to women who claim discrimination on the basis of comparable worth.

1985-87 "Comparable Worth Movement Goes on Despite Setbacks." *American Libraries* 16 (October 1985): 606.

Judges in Washington State rule against comparable worth.

1985-88 Lewis, Helen. "Job Evaluation: The University of Connecticut Experience." *Connecticut Libraries* 27 (October 1985): 6-7.

A useful and thorough account of one university's experience with the adoption and implementation of a job classification study that affected a bargaining unit including librarians. Although the union did not negotiate on the concept of pay equity, 90 percent of the employees receiving salary adjustments were women, minorities, or men in traditionally female jobs.

1985-89 McManamon, Ann. "Paycheck: The Issue of Comparable Worth." *Ohio Library Association Bulletin* 55 (October 1985): 11-17.

Judge McManamon counters arguments by pay equity opponents and suggests initiatives through collective bargaining, court actions, and governmental

action. Ohio's pay equity study and ALA's position on comparable worth are cited.

1985-90 Learmont, Carol L., and Van Houten, Stephen. "Placement and Salaries, 1984: No Surprises." *Library Journal* 110 (October 1, 1985): 59-65.

For the 34th year, placement and salaries of library school graduates are analyzed. Mean salary for men is $19,012, for women $18,703—a 7 percent increase. In actual numbers, a total of 1,909 women and 513 men were placed in library positions in 1984.

1985-91 "Personality Traits of Men in Female-Dominated Jobs." *Library Journal* 110 (October 1, 1985): 32.

Study of 117 men in Atlanta showed librarians to be "younger and more educated," to like shorter work weeks, and to be less likely to be married and more likely to come from a lower social-class background than men in male-dominated jobs.

1985-92 "Continuing Reports from Sessions of the Annual Conference of the American Library Association in Chicago, Ill." *Library of Congress Information Bulletin* 44 (October 28, 1985): 310-320.

Coverage of Federal Librarians' Round Table (FLRT) and pay equity are included here.

1985-93 Cargill, Jennifer. "A Conversation with Kathleen Heim." *Technicalities* 5 (November 1985): 3-8.

In answer to question regarding present status of women in librarianship, Heim states that women are earning more in information fields than in traditional library settings and notes that women must be assertive and aggressive in selling their abilities and must apply in greater numbers for top administrative positions.

1985-94 Hill, Janet Swan. "Wanted: Good Catalogers." *American Libraries* 16 (November 1985): 728-730.

Theorizes that the women's movement has been one of the contributing factors to the loss of good candidates for cataloging positions because it has opened up employment opportunities in nontraditional and male-dominated fields.

1985-95 "Legal Fruitcakism." *National Librarian* 10 (November 1985): 2.

Reprint of letter sent to ALA, RASD, LC, the Public Library Association (PLA), and the National Bureau of Standards requesting an explanation under threat of class action suit as to why terms such as *men's rights, father's rights, parent's rights, and male liberation* are not used as indexing terms in libraries operating with public funds.

1985-96 McReynolds, Rosalee. "A Heritage Dismissed." *Library Journal* 110 (November 1, 1985): 25-31.

The "image problem" is traced historically by comparing the roles women have played with the stereotypes of librarians. Fictional librarians are also described.

1985-97 Harris, Roma; Mitchel, B. Gillian; and Cooley, Carol. "The Gender Gap in Library Education." *Journal of Education for Library and Information Science* 25 (Winter 1985): 167-176.

Results of the identification of gender-related differences in teaching specialties are discussed with respect to their implications for library educators as sex-role models. Some library specialties, such as children's librarianship, are dominated by women, while information science is a male preserve.

1985-98 Rubin, Richard. "Turnover Rates of Librarians: A Pilot Study on Employee Turnover Rates of Librarians in Three Moderately Large Public Libraries in Ohio." *Journal of Library Administration* 6 (Winter 1985/86): 89-106.

Author finds a higher turnover rate for women librarians but cautions against drawing conclusions based on the small sample. Other mobility studies are discussed in reference to gender.

1985-99 St. Clair, Gloriana. "Editorial." *Texas Library Journal* 6 (Winter 1985): 6.

Salutes women in Texas librarianship on the occasion of the retirement of several notable librarians. Cites contributions of women in general to the profession.

1985-100 Wall, Celia. "Self-Concept: An Element of Success in the Female Library Manager." *Journal of Library Administration* 6 (Winter 1985/86): 53-65.

Examines the scholarly and popular literature on self-concept to demonstrate the importance of self-concept to women in or seeking library management positions.

1985-101 Bierman, Jan. "Career Development of Women Librarians in New Zealand." *New Zealand Libraries* 44 (December 1985): 225-227.

A survey of Auckland librarians shows women express limited career goals and/or motivation, hold same positions for longer periods than men, and enter profession at earlier age than men. Job mobility and work continuity are affected by family responsibilities.

1985-102 Little, Jane. "Women in Libraries." *New Library World* 86 (December 1985): 232-233.

Discusses issues confronting women in management. Other topics include the Feminist Book Fair and the 1986 Women in Libraries conference preparation.

1985-103 Manley, Will. "Facing the Public." *Wilson Library Bulletin* 60 (December 1985): 38-39.

Editorial criticizes the selection of a man as ALA Executive Director. Suggests that selection of a woman director would have helped overcome stereotyping of both male and female librarians.

1985-104 "TIAA-CREF Adjusts Benefits." *Library Journal* 110 (December 1985): 30.

Reports Spirt decision in favor of sex-neutral retirement benefits.

1985-105 "What Is Comparable Worth?" *Library Administrators' Digest* 20 (December 1985): 75.

Reprint of article from *USA Today* (September 6, 1985) defining *comparable worth* and citing examples of its implementation. Librarians are referred to as a party in a settlement in Los Angeles.

1985-106 Wilkins, Betsy, and Kirkpatrick, Liz. "The President's Corner." *Connecticut Libraries* 27 (December 1985): 3.

States the commitment of the Connecticut Library Association to pay equity and improving the public image of librarians. The authors suggest that the two issues are interrelated since they both stem from sexism and anti-intellectualism, and assert that it is the role of the professional association to provide a unified voice for these concerns.

1986-01 Bourdon, Cathleen. "Academic Libraries." In *ALA Yearbook of Library and Information Services '86*. Edited by Roger Parent. Chicago: American Library Assn., 1986: 29-35.

Summarizes Barbara B. Moran's *Academic Libraries: The Changing Knowledge Centers of Colleges and Universities* [1984-15] and notes that although not substantiated by research, it appears that the position of women in academic librarianship has improved.

1986-02 Daval, Nicola. "Association of Research Libraries." In *ALA Yearbook of Library and Information Services '86*. Edited by Roger Parent. Chicago: American Library Assn., 1986: 68-69.

Summarizes ARL salary survey for fiscal year 1986, with a breakdown by sex.

1986-03 Dowell, David Ray. "The Relation of Salary to Sex in a Female Dominated Profession: Librarians Employed at Research Universities in the South Atlantic Census Region." Ph.D. dissertation, University of North Carolina at Chapel Hill, 1986. (DAI 87-11107)

In this study, women earned almost $5,000 less than men, had less supervisory responsibility, completed fewer graduate degrees outside of library science, had less professional service in university-wide organizations, belonged to fewer professional organizations, and published less. More interestingly, when these

and twenty other factors were held constant, men still earned $1,200 more than women.

1986-04 Fretwell, Gordon. *ARL Annual Salary Survey 1985*. Washington, D.C.: Assn. of Research Libraries, 1986.

Table 12 includes distribution of professional staff in ARL university libraries by sex and position for fiscal year 1986. Tables 13 and 14 continue to report data on number of staff and average salaries, with a breakdown by sex; information on ARL minority university librarians is also included. Tables 15 and 16 continue to provide information on number of staff and average years of experience. In Table 16 data are shown by sex for ARL minority librarians. Tables 17 and 18 compare average salaries of men and women by years of experience, while Tables 25, 26, and 27 give the equivalent information for ARL university and minority university medical librarians. Tables 32 and 33 give equivalent information for law librarians.

1986-05 Grant, W. Vance, and Snyder, Thomas. *Digest of Education Statistics 1985-86*. Washington, D.C.: Govt. Print. Off., 1986.

Includes statistics from public school libraries and/or media centers, broken out by sex, and breaks down library science degrees by sex of student.

1986-06 Jones, Kay F. "Women in Librarianship." In *ALA Yearbook of Library and Information Services '86*. Edited by Roger Parent. Chicago: American Library Assn., 1986: 325-327.

Summary of published material on women in libraries, including information on salaries, female deans and directors, research publications, and activities of groups that focus on the status of women in libraries.

1986-07 Ladenson, Alex. "Law and Legislation." In *ALA Yearbook of Library and Information Services '86*. Edited by Roger Parent. Chicago: American Library Assn., 1986: 182-183.

Reports temporary setback in comparable-worth movement when U.S. Court of Appeals in San Francisco ruled that the State of Washington did not have to offer women equal pay for equal jobs of comparable worth; also summarizes Merwine case.

1986-08 Learmont, Carol L., and Van Houten, Stephen. "Placements and Salaries, 1984: No Surprises." In *Bowker Annual*. 31st ed. New York: Bowker, 1986: 307-322.

Thirty-fourth annual report on placement and salaries of graduates of ALA-accredited library education programs shows that the 1984 average (mean) beginning salary for women was $18,730, a 7 percent increase over 1983, and for men, $19,012, a 4 percent increase. [Adaptation of 1985-90].

1986-09 Leinbach, Philip E. "Personnel and Employment: Compensation and Pay Equity." In *ALA Yearbook of Library and Information Services '86*. Edited

by Roger Parent. Chicago: American Library Assn., 1986: 235-236, 239.

Summarizes annual *Library Journal* survey showing average beginning salaries as $19,012 for men and $18,730 for women; also notes salary discrepancy in men's and women's salaries in ARL libraries—$31,952 vs. $28,104. "Pay Equity" section summarizes 1985 pay equity actions.

1986-10 Person, Ruth J., and Ficke, Eleanore R. "A Longitudinal Study of the Outcomes of a Management Development Program for Women in Librarianship." In *Advances in Library Adminstration and Organization*. Greenwich, Conn.: JAI Pr., 1986: 1-13.

Study of participants in an "institute" that focused on teaching management techniques to librarians discovered that the continuing education program affected perceived opportunities for career advancement; the likelihood of contributions toward developing the potential of other women librarians; and, most importantly, the ability to network. This study of the women who were involved in the institute is considered likely to provide more information about career patterns in the years to come.

1986-11A Purcell, Gary R. "Faculty." In *Library and Information Science Education Statistical Report 1986*. State College, Pa.: Assn. for Library and Information Science Education, 1986: 1-85.

Thirteenth survey of faculty information pertaining to library education includes tables showing male-female ratio of full-time faculty in ALA-accredited programs from 1976 to 1986, changes in male-female ratio of full-time faculty from 1975-1976 to 1985-1986, and age categories of sixty heads of ALA-accredited programs, divided by sex. Also compares male and female faculty salaries; gives percentage of full-time faculty with earned doctorates, divided by sex; and shows tenure status by rank and sex.

1986-11B Sparks, C. Glenn. "Students." In *Library and Information Science Education Statistical Report 1986*. State College, Pa.: Assn. for Library and Information Science Education, 1986: 86-152.

Includes information on enrollment, by program and sex, based on official enrollment in the fall 1985 term; and on degrees and certificates awarded, divided by sex and ethnic origin. Also gives a profile of students by sex and ethnic origin; gives number of foreign students enrolled in the fall 1985 term, in ALA- and non-ALA-accredited programs by program level and sex; and gives data on students enrolled, by age and sex, and on scholarships and assistantships awarded to students officially enrolled in 1984-1985, by amount, sex, and program level. In fall 1985 in fifty-seven schools reporting, there were 792 men and 2,267 women enrolled in master's degree programs. At the doctoral level, there were fifty-eight men and ninety women in the twenty schools reporting.

1986-11C Daniel, Evelyn. "Summary and Comparative Analysis." In *Library and Information Science Statistical Report 1986*. State College, Pa.: Assn. for

Library and Information Science Education, 1986: 251-266.

Summary provides analysis and annual comparative tables of students and faculty by sex. Of this year's graduates, 78 percent were women, as opposed to 80 percent in the previous year. In faculty reporting, it is noted, for example, that women deans earned 87.1 percent of what their male colleagues brought in, whereas ten years previously they earned 95.7 percent of the male deans' average salary.

1986-12 Schlachter, Gail A. "Abstracts of Library Science Dissertations." In *Library Science Annual*, vol. 2. Edited by Bohdan S. Wynar. Littleton, Colo.: Libraries Unlimited, 1986.

Introduction notes that although women constituted the majority of practicing librarians, they authored a minority of library science dissertations from 1925 to 1979. In 1980 and 1981 women authored more than 50 percent of dissertations, but the figure dropped to 45 percent in 1983 and 46 percent in 1984. The typical dissertation for the Ph.D. degree continues to be written by a male.

1986-13 *SLA Triennial Salary Survey 1986*. Washington, D.C.: Special Libraries Assn., 1986.

Introduction notes that in every percentile rank, the salaries reported by female members in 1985 were smaller than the salaries reported by males. Average mean reported for females in the United States was $28,049, while the same figure for males was $33,320.

1986-14 Summers, William F. "Education, Library." In *ALA Yearbook of Library and Information Services '86*. Edited by Roger Parent. Chicago: American Library Assn., 1986: 131-132.

Summarizes ALISE statistical reports on library school faculties and students, as well as *Library Journal* survey on placement and salaries.

1986-15 U.S. Department of Labor. Bureau of Labor Statistics. *Occupational Outlook Handbook 1986/87*. Washington, D.C.: Govt. Print. Off., 1986. (L2.3/4: 986-87)

Vocational guidance information on librarians includes a photograph of a female librarian answering requests for information.

1986-16 U.S. Department of Labor. Bureau of Labor Statistics. *Occupational Projections and Training Data*. Washington, D.C.: Govt. Print. Off., 1986. (L2.3/4-2: 986)

Statistical and research supplement to the *1986-87 Occupational Outlook Handbook* contains an employment profile for librarians, noting selected characteristics of workers in 1984, (e.g., percent female) and, in the supply profile, characteristics of entrants. States that "older entrants generally are women returning to work after tending to household responsibilities."

1986-17 U.S. Library of Congress. *Librarian of Congress Annual Report 1985.* Washington, D.C.: Govt. Print. Off., 1986. (LC1.1: 985)

Activities of the Library of Congress mentioned include those of the Equal Employment Opportunity Programs, Affirmative Action Office, and the 10th anniversary celebration of the Women's Program Office (pp. 12-13, 25).

1986-18 Vetter, Betty M., and Babco, Eleanor. *Professional Women and Minorities—A Manpower Data Resource Service.* 6th ed. Washington, D.C.: Commission on Professions in Science and Technology, 1986.

Presents current and historical statistics about women and minorities in the professional segment of the population. Several tables on bachelor's, master's, and doctoral degrees awarded to women by field and on employed persons by occupation, sex, and race include librarianship.

1986-19 Little, Jane. "Women in Libraries." *New Library World* 87 (January 1986): 51.

Notes sexism in publishing practices and announces that the 6th Women in Libraries Conference will feature Dale Spender as one of the speakers.

1986-20 Nyren, Karl. "News in Review, 1985." *Library Journal* 111 (January 1986): 31-41.

In section titled "Placements and Salaries," Nyren reports that acceptance of "comparable worth" promised better salaries for both male and female librarians in Los Angeles.

Letter:

Holmes, Fontayne. "Pay Equity in L.A." *Library Journal* 111 (April 15, 1986):16. Letter gives facts and figures supporting Nyren's claim of benefits from comparable worth in Los Angeles.

1986-21 "Pay Equity and 'Good Pay' Discussed at NJLA Institute." *Library Journal* 111 (January 1986): 22.

Summarizes presentations by Sue Galloway, project director of the ALA Institute on Pay Equity (1986), and Herbert S. White, titled "Money: Why Don't We Make More?" sponsored by the New Jersey Library Association (NJLA) and the New Jersey State Library.

1986-22 "U.S. District Court Finds Against Lourdes Deya in Sex Discrimination Suit." *Wilson Library Bulletin* 60 (January 1986): 10.

News item reporting the results of a suit against Louisiana State University for failure to promote for reasons of sex and national origin.

1986-23 "Two New Publications on Women in Librarianship." *Catholic Library World* 57 (January/February 1986): 155.

Describes bibliography updates and COSWL fact sheets.

1986-24 "Semiannual Report on Developments at the Library of Congress, April 1, 1985, Through September 30, 1985." *Library of Congress Information Bulletin* 45 (January 6, 1986): 3-28.

Describes achievements in the areas of the Administrative Detail Program, data corrections, sexual harassment, women in management, day care, etc.

1986-25 Swigger, Keith. "Librarians and Dual Career Marriages: A Study of Texas Woman's University Alumnae." Paper presented at the Annual Meeting of the Association for Library and Information Science Education, January 6, 1986.

Survey of a random sample of Texas Woman's alumnae identifies the "typical librarian" as female, married, with two children, and working full time. Marriage appears to create no significant differences in attitudes toward careers; however, geographical mobility is noted to be limited by spouse. (Available as ED 273 282).

1986-26 "Comparable Worth Scores in Washington and Chicago." *American Libraries* 17 (February 1986): 92.

One thousand librarians and library clerks in Chicago will receive a 19.2 percent pay increase as a result of a white-collar worker union contract. Also, a half dozen library employees will benefit from a comparable-worth increase in Washington.

1986-27 "Wyo. Female Directors Earn Less Pay." *The Outrider* 18 (February 1986): 1, 3.

Wyoming State Library figures show women library directors earning less than their male counterparts.

1986-28 de Gooijer, Jinette. "Status of Women in Librarianship Special Interest Group." *InCite* 7 (February 7, 1986): 6.

Describes presentation by Dr. Jocelynne Scutt on *Sharing Our Words: A Select Guide to Feminist Writings*, which was produced by the Women's Information and Referral Exchange in Melbourne, Australia.

1986-29 Carmichael, James V., Jr. "Atlanta's Female Librarians, 1883-1915." *Journal of Library History, Philosophy, and Comparative Librarianship* 21 (Spring 1986): 376-399.

During this time period, women librarians dominated library education, service, and leadership in Atlanta. Careers of several women are highlighted. Includes photographs, tables of ALA membership, and characteristics of Carnegie Library School graduates from 1906-1915.

1986-30 "Don't Forget Your Librarian When Writing Job Descriptions for Women's Studies." *NWSA Perspectives* 4 (Spring 1986): 14.

A plea from *Perspectives* editor and a librarian, Nancy Seale Osborne, to include liaison with the library as a part of women's studies job descriptions.

1986-31 Fasick, Adele M. "Library and Information Science Students." *Library Trends* 34 (Spring 1986): 607-621.

Offers a discussion of early library training, in which Fasick notes that Dewey, in establishing formal training for new librarians, made library work attractive to newly educated women and led the way to librarianship's becoming one of the first professions in which women outnumbered men. However, through the years, "the great librarians" and administrators of the profession were men with little or no formal training, whereas most library school graduates were women who held the lower positions and fit the library ideal of service to the profession. Fasick also examines library students today and concludes that as new career choices become available to women, library school programs will have to compete to attract first-rate students.

1986-32 "Librarians' Task Force." *NWSA Perspectives* 4 (Spring 1986): 16.

Call for papers for task force panels for the 1986 National Women's Studies Association (NWSA) conference.

1986-33 Scott, Anne Firor. "Women and Libraries." *Journal of Library History, Philosophy, and Comparative Librarianship* 21 (Spring 1986): 400-405.

Library historians have failed to examine the role of women's associations in establishing public libraries and the resulting impact on American culture.

1986-34 Smith, Virginia. "Librarianship: A Female Intensive Occupation." *Current Studies in Librarianship* 10 (Spring/Fall 1986): 53-60.

Contains an overview of previous research and a summary of possible strategies for empowering women librarians and enhancing their position in librarianship, including joining feminist librarian groups (e.g., ALA-SRRT Feminist Task Force and Women Library Workers).

1986-35 Wheeler, Helen. "Libraries as Feminist Resources." *NWSA Perspectives* 4 (Spring 1986): 13-14.

Describes activities of feminist librarians in Japan to network and promote the collection of women's studies materials.

1986-36 Little, Jane. "Women in Libraries." *New Library World* 87 (March 1986): 51.

Points out that in the process of book selection, the male-dominated commercial publishers first select what will be published, then the male-dominated field of library suppliers pre-selects titles for approval collections. Finally, librarians must make final stock selections and contend with censorship charges. Author concludes that the new "liberalization" has not benefited women.

1986-37 "Pay Equity Commission Plans ALA Preconference." *School Library Journal* 32 (March 1986): 87.

Announces preconference to be held before the ALA Annual Conference in New York.

1986-38 White, Herbert S. "Why Don't We Get Paid More?" *Library Journal* 111 (March 1, 1986): 70-71.

Expresses the viewpoint that pay equity action is only one channel for improving salaries in librarianship and that the law of supply and demand can be a powerful force if librarians will take themselves seriously and concentrate on economic issues, as other professions do.

1986-39 Berry, John. "Tension, Stress, and Debate." *Library Journal* 111 (March 15, 1986): 29-31.

In this review of the Annual Conference of the Association for Library and Information Science Education under the section "Research Stars," Berry notes a report by Ellen Gay Detlefsen for library school women on the relationship between librarianship careers and families.

1986-40 Bryan, Gordon Tom. "The Liberated Skeleton." *Emergency Librarian* 10 (March-April 1986): 12-15.

Summarizes the literature about the problem patron and includes the concern that behavior is often directed at women and is therefore an issue of women's groups in librarianship and in the community. Annotated bibliography.

1986-41 Bobinski, George. "Doctoral Programs in Library and Information Science in the United States and Canada." *Library Trends* 34 (April 1986): 697-714.

Discusses development, status, and future of doctoral programs. Enrollment statistics from 1979 to 1954 include breakdown by sex and show an increase in the number of part-time women students.

1986-42 Gerhardt, Lillian Noreen. "Look What's Happened to Linda." *School Library Journal* 32 (April 1986): 2.

Discusses sex discrimination charges filed by Linda Silver because of denial of promotion from Deputy Director to Executive Director of Cuyahoga County (Ohio) Public Library. The situation exemplifies why there are fewer people entering the library profession: "There is no longer a ready, steady supply of young women willing to enter library service and become part of its 80 percent female majority while over 80 percent of all the top library jobs in any specialty of library service are held by men."

1986-43 Goodyear, Mary Lou. "Librarians and Pay Equity: The Economic Argument." *Show-Me Libraries* 37 (April 1986): 7-9.

Discusses economic arguments against pay equity and proposes use of job classification techniques to correct discriminatory wage practices.

1986-44 "Ohio Librarian Files Sex Discrimination Charges Against Board of Trustees." *American Libraries* 17 (April 1986): 233.

Reports filing of sex-discrimination suit by Linda R. Silver because her

candidacy for director of the Cuyahoga County Public Library (Cleveland) was rejected twice.

1986-45 "On Pay Equity." *Show-Me Libraries* 37 (April 1986): 5-6.

Defines *pay equity*, outlines ALA support for the concept of pay equity, and summarizes some pay equity gains on state and national levels.

1986-46 Van House, Nancy. "Salary Determination and Occupational Segregation Among Librarians." *Library Quarterly* 56 (April 1986): 142-166.

Study of individual characteristics that determine librarians' salaries looks to see if earnings differ across library types and sexes, and uses these functions to test explanations for librarianship as female intensive and for the disproportionate distribution of sexes in the profession.

1986-47 "Wyoming Women Directors Earn Less." *American Libraries* 17 (April 1986): 235.

Results of a public libraries annual report reveal that women directors earn $14,000 less than men. Wayne Johnson, Wyoming State librarian, says that this is the second year he has reported the ratio. "Once again, the news created considerable media coverage, but no action."

1986-48A *Bibliophile* (Newsletter of the University of Maryland College of Library and Information Science) 10 (April 15, 1986): whole issue.

Special issue "designed to help University of Maryland library school women take an active part in examining, coping, and acting on some of the important issues facing women today."

1986-48B Humphreys, A. C. "Lesbians and Gays in Librarianship: On a Clear Day You Can See the Second Class." *Bibliophile* 10 (April 15, 1986): 3.

Urges sexual-orientation protection in employment contracts and denounces *American Libraries* article "Marryin' the Librarian" (January 1986) as perpetuating a falsehood that all librarians and librarian couples are "straight."

1986-48C Radick, Sarah K. "The Unassertiveness Trap." *Bibliophile* 10 (April 15, 1986): 8-9.

Cites survey done that finds new women entrants to the College of Library and Information Service to have a level of assertiveness that contradicts the stereotyped image of the "retiring" librarian.

1986-48D "Pay Equity Facts—Compiled from the National Committee on Pay Equity." *Bibliophile* 10 (April 15, 1986): 9.
Contains a few facts about comparable worth and librarianship.

1986-48E Palmer, Lene. "Make My Day—Up My Salary." *Bibliophile* 10 (April 15, 1986): 10-11.

Notes placement and salary data as compiled in the *Bowker Annual* and other sources. Sees an upward trend in salaries for women librarians.

1986-48F "A Woman's Profession? An Open Letter to the Press." *Bibliophile* 10 (April 15, 1986): 12-13.

Asks that library press respond to social issues affecting librarians rather than leave political action to the alternative press.

1986-49 "New Members Named to Women's Program Advisory Committee." *Library of Congress Information Bulletin* 45 (April 21, 1986): n.p.

Describes committee role and identifies names and departments of those selected.

1986-50 "ALA Preconference on Pay Equity." *Connecticut Libraries* 28 (May 1986): 28.

Announcement of the Institute on Pay Equity to be held before the 1986 ALA Conference endorses the issue as a priority concern for the Connecticut Library Association.

1986-51 "Pay Equity Action." *NYLA Bulletin* 34 (May 1986): 4.

Reports charge to the New York Library Association (NYLA) to support the New York State Equity Committee and legislation related to pay equity.

1986-52 "Salary Survey Shows Gains in University, Special Libraries." *American Libraries* 17 (May 1986): 303.

Notes that the *SLA Triennial Salary Survey* showed mean salary of female SLA members as $28,049, with males at $33,320, yet female rate of increase was 8.4 percent compared with male rate of 6.8 percent.

1986-53 "Women's History." *NYLA Bulletin* 34 (May 1986): 10.

Describes a bus tour of Rochester, New York, sponsored by the New York Library Association Round Table on the Concerns of Women.

1986-54 Anderson, A. J. "I'm Being Sexually Harassed." *Library Journal* 111 (May 15, 1986): 44-47.

Describes a sexual harassment situation and is followed by analysis of the situation and methods of handling it. Those analyzing the situation and offering solutions include William M. Andrews, "Written Accounts, Weekly Meetings"; Jo Cates, "How Do You Solve a Problem Like Murray?"; and Judith Carhart, "Follow University Policy."

Letters:

Segesta, Jim. "Better Label for Harassment." *Library Journal* 111 (August 1986): 6. Suggests that Laurie York drop the terminology *sexual harassment* and simply emphasize her right not to be touched.

Lettus, Dorothy M. "Don't Tolerate Harassment." *Library Journal* 111 (September 15, 1986): 11. Takes issue with Cates's recommendation that the harassed worker look for another job while she still has this one and concludes that women and workers have rights and an employer should protect those rights.

1986-55 Beghtol, Clare. "The Gender Gap in Library Education and Publication." *Journal of Education for Library and Information Science* 27 (Summer 1986): 12-30.

Author discusses the findings of Harris et al. [1985-97] in the context of author's research on publication activity. Author concludes that the clustering of teaching faculty by subject in library and information science does not necessarily reflect the traditional roles of men and women.

1986-56 Carrick, Kathleen. "Silk vs. Corduroy: The Status of Men and Women in Law Librarianship." *Law Library Journal* 78 (Summer 1986): 425-441.

Updates the 1971 [1971-12] survey of the American Association of Law Libraries membership. Salary data indicate that while 20.32 percent of women earn more than $25,000, the percentage for men is 48.1. Women also supervise fewer employees, are less mobile, and are more likely to have more interrupted careers. Concludes with interpretations and implications of the data and the relationship to other research on employment and salaries.

1986-57 Goetsch, Lori A. "Librarianship, Professionalization and Its Impact on Work Environment." *NWSA Perspectives* 4 (Summer 1986): 7-8.

Discusses the effects of professionalization on feminist concepts of work and the relationship between librarians and support staff.

1986-58 Harris, Roma M. "Career Aspirations of MLS Students: Yes, the Women Are As Ambitious As the Men." *Journal of Education for Library and Information Science* 27 (Summer 1986): 31-37.

Students enrolled at the University of Western Ontario's School of Library and Information Science were studied with respect to their career commitment. There were eighty-eight female and thirty-seven male students participating, and findings showed no significant differences in responses by sex in relation to career ambition, specificity, or certainty about commitment to the profession.

1986-59 "Librarians' Task Force." *NWSA Perspectives* 4 (Summer 1986): 20-21.

Task force panels "Bringing Global Feminism into Libraries" and "Working for Change: Librarians as Activists" are reported.

1986-60 Rhoades, Alice J. "Early Women Librarians in Texas." *Texas Libraries* 47 (Summer 1986): 46-53.

Reviews the education and careers of six librarians at the turn of the century: Julia Bedford Ideson, Jennie Scott Scheuber, Maud Durlin Sullivan, Julia Grothaus, Lillian Gunter, and Elizabeth Howard West. Concludes that while the six shared social characteristics of professional women at that time—single, white, middle class—their careers differed greatly from the stereotypical image of the woman librarian as a low-status clerk.

1986-61 Harris, Roma M.; Monk, Susan; and Austin, Jill T. "MLS Graduate Survey: Sex Differences in Prestige and Salary Found." *Canadian Library Journal* 43 (June 1986): 149-153.

A survey of graduates, mailed to 2,056 graduates, of the University of Western Ontario School of Library and Information Science brought results on the perceived prestige of twenty professional tasks and twenty work settings. Perception of the prestige of tasks did not differ significantly between women and men. For example, both ranked school library positions lowest. Other position, salary, and sex data were analyzed and reported on the approximately 670 respondents.

1986-62 Little, Jane. "Women in Libraries." *New Library World* 87 (June 1986): 110.

Little discusses censorship, feminist book promotion, and Dale Spender's presentation at the Women in Libraries Conference.

1986-63 Wiener, Paul B. "Misguided Tours." *American Libraries* 17 (June 1986): 404.

Letter writer criticizes Intellectual Freedom Round Table's "feminist-guided tour of Times Square pornographic district" during ALA Conference.

Letter:

Schneider, Donna. "Free-Speech Defenders Overlook Sexism." *American Libraries* 17 (September 1986): 584. Response to Wiener's letter notes that feminists are attempting to raise consciousness that certain pornography can demean within a sexual context and that the ALA tour can serve to familiarize people with the materials in question.

1986-64 "Women on the Library Ladder: They're Headed Upward, but a Few Rungs Are Missing." *American Libraries* 17 (June 1986): 472, 475, 477.

Reviews research by Mary Niles Maack on women in library education, by Betty Jo Irvine on sex differences in academic library administration, and by Joy Greiner on career development patterns of public library administrators.

1986-65 "New York, New York: Selected Tours from the ALA Program." *Library Journal* 111 (June 1, 1986): 67.

Notes that "feminist-guided" tours of the porn district will be conducted by Women Against Pornography during ALA Conference.

1986-66 Wagner, C. "No More Weeping and Accusing." *Library Journal* 111 (June 1, 1986): 16.

Letter responds to an article by Herb White, "Respect for Librarians" (*Library Journal*, February 1, 1986: 58-59), and suggests that, among other factors, librarianship as a women's occupation contributes to the lack of proper respect and adequate salaries for the profession.

1986-67 "Semiannual Report on Developments at the Library of Congress October 1, 1985, Through March 31, 1986." *Library of Congress Information Bulletin* 45 (June 16, 1986): 215-237.

Reports activities of the Woman's Program Office and selection of a new Woman's Program Advisory Committee.

1986-68 "Herb White Raises Hackles at Session on Raising Salaries." *American Libraries* 17 (July/August 1986): 541.

Describes debate on how to best raise librarians' salaries, in which Helen Lewis terms the problems of sex-based salary inequities and low librarianship-pay scales as so huge that they require unionization for change, while Herb White argues against unions.

1986-69 Berry, John. "Problem of Government." *Library Journal* 111 (August 1986): 35-54.

Report of ALA's Annual Conference includes special sections on ALA women's groups and pay equity.

1986-70 "CC/NLA on Pay Equity." *National Librarian* 11 (August 1986): 2-3.

Reprint of a policy statement adopted by the California Chapter of the National Librarians Association (CC/NLA).

1986-71 Norman, Sandy, and Thomason, Barbara. "Images of Women: Women in Libraries Sixth Annual Conference." *Library Association Record* 88 (August 1986): 384-385.

Report of three speakers: Dale Spender, Femi Otituje, and Sue Adler at the Sixth Annual Conference sponsored by Women in Libraries.

1986-72 "The SLA Success Story." *Library Journal* 111 (August 1986): 55-60.

Reports findings of the "Super Survey" conducted in April 1986, which show that 85 percent of SLA members are female.

1986-73 "Knitting for Feminists." *InCite* 7 (August 22, 1986): 15.

Review of *Sharing Our Words: A Select List of Feminist Writings*, published by the Library Association of Australia's Status of Women in Librarianship Special Interest Group.

1986-74 Malone, Mary Frances. "The Salary Survey in Perspective." *Special Libraries* 77 (Fall 1986): 240-241.

Data indicate that men earned 18 percent more than women at the entry level and 27 percent more in upper-level positions.

1986-75 [Untitled.] *Top of the News* 43 (Fall 1986): 13-14.

Announcement and call for papers for the Librarians' Task Force panel at the 1987 National Women's Studies Association Annual Conference.

1986-76 "Terrorism, Violence, and Patron Confidentiality: Library Censorship Issues of the '80s?" *Wyoming Library Roundup* 42 (Fall 1986): 47-49.

Nora Van Burgh, one of the panelists at a 1986 Wyoming Library Association conference program, gives her opinions on pornography and censorship from the perspective of a feminist librarian.

1986-77 Varlejs, Jana, and Dalrymple, Prudence. "Publication Output of Library and Information Science." *Journal of Education for Library and Information Science* 27 (Fall 1986): 71-89.

Tables 13-15 display publication activity by sex and reveal "striking differences . . . male productivity is greater on almost all points." Authors discuss findings in light of other research on women on library school faculties.

1986-78 Garson, Marjorie, and Dattalo, Elmo F. "Sexism at the Annual Meeting." *American Association of Law Librarians Newsletter* 18 (September 1986): 44.

Authors record their objections to the sexism implicit in an introduction for AALL President Laura Gasaway.

1986-79 Mellor, Earl F. "Weekly Earnings in 1985: A Look at More Than 200 Occupations." *Monthly Labor Review* 109 (September 1986): 28-32.

Summary based on data from the Current Population Survey (CPS) reveals median weekly earnings of wage and salary workers who usually work full time. Data by sex, including percentage of female workers, are included for librarians, archivists, and curators.

1986-80 "More Than a Feminist Issue." *Wilson Library Bulletin* 61 (September 1986): 30.

Reports on the meeting of the Pay Equity Commission at the 1986 Annual Conference in New York.

1986-81 "The Well-Behaved Librarian." *Wilson Library Bulletin* 61 (September 1986): 28.

Describes ALA Annual Conference program sponsored by the Committee on the Status of Women in Librarianship and the SRRT Feminist Task Force, featuring civil rights activist Flo Kennedy.

1986-82 Jones, Kay F. "Sex, Salaries, and Library Support." *Library Journal* 111 (September 1, 1986): 145-153.

Biannual survey of public librarians by the Allen County Library of Fort Wayne, Indiana, reveals men at the top two to one, but the male advantage appears to be decreasing. Data are displayed in sixteen tables, most of which are broken out by sex.

1986-83 Romanko, Karen A. "A Librarian Lets Her Hair Down." *Publishers Weekly* 230 (September 12, 1986): 88.

Editorial on librarian stereotypes depicted in the media. Cites the feminization of librarianship as contributing to the image problem.

1986-84 de Gooijer, Jinette. "Status of Women in Librarianship." *InCite* 7 (September 19, 1986): 4.

Notes that ALA Treasurer Patricia Schuman spoke to group on feminist issues and American librarianship. Other activities of the year are also described.

1986-85 Dymke, Mary. "Professional and Parent: Maintaining the Balance." *Connecticut Libraries* 28 (October 1986): 1, 8-9.

Child care and child-care needs are examined by a survey of Connecticut libraries. A majority of respondents replied that child care is provided in a home. Advice on making child-care arrangements is offered.

1986-86 "Michele Leber Chairs New Pay Equity Committee." *American Libraries* 17 (October 1986): 720.

The appointment of Leber from the Fairfax, Virginia, County Public Library to head the new ALA Council committee that replaced the Executive Board Commission on Pay Equity is announced.

1986-87 Myers, Margaret. "Japanese Feminist Uses ALA Techniques to Advance Women's Status in Libraries." *American Libraries* 17 (October 1986): 662.

Information about Yoko Taguchi from Kyoto Seika College in Japan, who is the founder of the Feminist Librarians Network (FLINT) in Japan, notes that women librarians make up 50 percent of the library work force in Japan but direct only 3 percent of academic and public libraries.

1986-88 Ozinga, Connie Jo. "Division on Women to Meet Nov. 13-14 in Nashville." *Focus on Indiana Libraries* 40 (October 1986): 1.

News story announces fall workshop on leadership and communication skills sponsored by the Indiana Library Association's Division on Women in Indiana Libraries.

1986-89 Salter, Elaine. "The Women in Libraries Conference 1986." *New Library World* 87 (October 1986): 199.

The proceedings of the conference "Images of Women" will be published in *WILPower*, the newsletter of the Women in Libraries (WIL) group.

1986-90 Sellen, Betty-Carol. "T-Shirts a Tacky Tactic." *American Libraries* 17 (October 1986): 666.

T-shirts designed by the Louisiana Library Association depicting a lady with a bun are seen as furthering a stereotyped image.

1986-91 Watson, Jean. "Don't Ban the Bun." *American Libraries* 17 (October 1986): 666.

Don't judge a librarian by her hairdo.

1986-92 "Women in Libraries Conference, March 1986." *New Library World* 87 (October 1986): 119.

Describes "Images of Women" conference featuring Dale Spender as keynote speaker.

1986-93 Learmont, Carol L., and Van Houten, Stephen. "Placement and Salaries, 1985: Little Change." *Library Journal* 111 (October 15, 1986): 31-38.

Annual salary survey of ALA-accredited library programs reports beginning salaries for women increased 5 percent over 1984, while men's increased 6 percent; median salary for women was $19,000, compared with $19,500 for men. Includes tables.

1986-94 "Historian Says Role of Women's Groups Ignored in Writing of Public Library History." *American Libraries* 17 (November 1986): 782.

Reports charge by Duke University historian Anne Firor Scott [1986-33] that historians have failed to examine the role of women's associations in creating public libraries.

1986-95 "Images of Women." *Assistant Librarian* 79 (November 1986): 151.

Announcement of the publication of Women in Libraries' Sixth Annual Conference proceedings.

1986-96 "More Male Librarians." *Library Administrator's Digest* 21 (November 1986): 21.

Describes the results of a survey showing an increase from 12 percent to 18 percent in the number of men in librarianship. Encourages recruitment and hiring of men "if only to raise the level of library salaries." Also notes that the field is a good one for men interested in administration because "one can generally become head of a library system at an earlier age than he could become head of a school system or any other public service, to say nothing of the private sector."

1986-97 Plotnik, Art. "Library Vartanization or, the New Supra-Chiefs." *American Libraries* 17 (November 1986): 736.

In a discussion of the practice of hiring nonlibrarian supra-men as heads of major libraries, Plotnik notes that there are many librarians "who happen to be women" who have conclusively demonstrated the ability to "make things happen."

1986-98 Taguchi, Yoko. "Visit Ms. Myers at ALA." *Toshokan zasshi* (November 1986): 696-703.

Author interviews Margaret Myers of ALA Headquarters staff about issues relating to the status of women in librarianship in the United States and the activities of women's groups.

1986-99 Bailey, Joanne Passet. "The Rule Rather Than the Exception: Midwest Women as Academic Librarians, 1875-1900." *Journal of Library History, Philosophy, and Comparative Librarianship* 21 (Winter 1986): 673-692.

Study suggests that although the stereotype of the nineteenth-century academic librarian is a male college professor, in Illinois, Indiana, Michigan, Ohio, and Wisconsin, women participated in academic library administration from the mid-1870s and were actually in the vanguard of the transformation of academic librarianship from a part-time custodial position to a full-time profession.

1986-100 "Librarians' Task Force." *NWSA Perspectives* 4 (Winter 1986): 22.

Describes activities and resources of the task force.

1986-101 Maack, Mary Niles. "Women in Library Education: Down the Up Staircase." *Library Trends* 34 (Winter 1986): 401-432.

Offers a feminist perspective on the history and status of women library educators over three time periods: 1887-1923, 1924-1950, and 1951-1985. Concludes that as professionalization of the field increased, the status of women declined as a result of various factors, including gender socialization and sex discrimination.

1986-102 Miller, Connie. "The Library as an Information Conscience." *NWSA Perspectives* 4 (Winter 1986): 15-16.

Comments on the omission of libraries from Dale Spender's *Women of Ideas and What Men Have Done to Them*, a book that discusses the erasure of women from societal record. Miller proposes that since libraries exist to preserve information, they have played a role, through their passivity, in eliminating women from the record.

1986-103 Reed, Mary Hutchings. "Employment Discrimination and Related Litigation in Libraries." *Journal of Library Administration* 7 (Winter 1986): 53-66.

Article highlights cases illustrating employment discrimination in libraries. Cases summarized involving sex discrimination are the Merwine case and *Lanegan-Gumm vs. Library Association of Portland*.

1986-104 Rossiter, Margaret. "Women and the History of Scientific Communication." *Journal of Library History, Philosophy, and Comparative Librarianship* 21 (Winter 1986): 39-59.

Discusses women's involvement in scientific communication, both as librarians and as bibliographers, and the barriers against women in the sciences. Encourages research to further uncover the role of women in the history of science, in scientific librarianship, and in scientific communication.

1986-105 Bradley, Carol Jane. "Notes of Some Pioneers. America's First Music Librarians." *Notes* 43 (December 1986): 272-291.

Includes lengthy description of Barbara Duncan, who "may have been the

first woman to make music librarianship a career" and was the first secretary of the Music Library Association. Many other women are also mentioned.

1986-106 "Info. Clout for Women to Be Focus of 1988 Pre-IFLA Program." *American Libraries* 17 (December 1986): 854.

Announces program "To Give or Not to Give—Women and the Power of Managing Information" sponsored by the Library Association of Australia's Status of Women in Librarianship section. Focuses on women as service providers and as patrons.

1986-107 "San Francisco Votes for Pay Equity." *American Libraries* 17 (December 1986): 825.

Under a new comparable worth law, librarians are among a group of city employees to receive pay hikes.

1986-108 Sellen, Betty-Carol, and Johanson, Cynthia J. "COSWL: The Rights of the Majority." *American Libraries* 17 (December 1986): 866-867.

Highlights the founding, history, contributions, and future of the American Library Association's Committee on the Status of Women in Librarianship.

1986-109 "Update on the Women's Program Advisory Committee." *Library of Congress Information Bulletin* 45 (December 15, 1986): 1-2.

Summarizes the composition and organization of the Women's Program Advisory Committee and its role as advisor to the Women's Program Coordinator.

1986-110 "Women's Program Office to Hold Meeting on Child Care." *Library of Congress Information Bulletin* 45 (December 29, 1986): staff news.

Program on child care includes a panel presentation on the Library of Congress's decision to provide child care to staff by supporting renovations for a local child-care facility.

AUTHOR INDEX

107

TITLE INDEX

Abstracts of library science dissertations, 1985-16, 1986-12

Academic librarians, 1985-10

Academic librarians' attitude toward librarianship in the tri-state area: Pennsylvania, Ohio, and West Virginia, 1983-22

Academic libraries, 1984-12, 1986-01

Academic libraries: the changing knowledge centers of colleges and universities, 1984-15

Academic library administration: power as a factor in hiring and promotion within a feminized profession, 1984-11

Academics abroad: U.S. librarians visit the Peoples Republic of China, 1985-83

Access for minorities and women to administrative leadership positions: influence of the search committee, 1983-71

ACRL in Minneapolis, 1982-64

Affirmative action and library science degrees: a statistical overview, 1973-74 through 1980-81, 1983-72

Affirmative action at the Library of Congress: a historical overview, 1982-130

Affirmative action in public libraries and state library agencies, 1983-09B

Affirmative action reports: despite the White House chill, libraries maintain effort, 1985-31

ALA and the ERA: looking back on the association's political and fiscal involvement, 1982-134

ALA and the ERA, 1983-29

ALA and the Merwine case: a word as to the whys, 1984-103

ALA charges OPM federal librarian standards revision unfair and sexist, 1982-131

ALA Council votes to rescind "ERA boycott," 1982-93

ALA Councilor's corner, 1982-118

ALA Councilor's report, 1982-100

ALA Councilor's report: 101st annual conference, 1982-112

ALA elected to pay equity board, 1985-81

ALA elections: 1984, 1984-64

ALA Executive Board approves Hewitt study, 1983-89

ALA Executive Board eyes LSCA, data base, ERA, 1982-90

ALA fact sheets on status of women in librarianship, 1985-62

ALA favors pay equity bills, rejects OPM monitoring, 1984-84

ALA meets in Quaker City: a conference report, 1982-103

ALA midwinter preview, 1984-118

ALA moves up in the councils of comparable worth, 1985-85

ALA 1982 annual conference council report, 1982-111

SUBJECT INDEX

academic librarians, 1982-03, 1982-07,
1982-11, 1982-14, 1982-15, 1982-21,
1982-27, 1982-30, 1982-34, 1982-101,
1982-108, 1982-137, 1983-06, 1983-
20, 1983-22, 1983-28, 1983-65, 1983-
76, 1983-83, 1983-93, 1984-04, 1984-
05, 1984-09, 1984-11, 1984-12, 1984-
15, 1984-21, 1984-33, 1984-34, 1984-
46, 1984-60, 1984-69, 1984-81, 1984-
87, 1984-92, 1984-101, 1985-06,
1985-09, 1985-10, 1985-22, 1985-35,
1985-49, 1985-80D, 1985-80F, 1986-
01, 1986-02, 1986-03, 1986-04, 1986-
05, 1986-64, 1986-99
academic libraries, 1982-07, 1983-20,
1984-04, 1984-09
Adler, Sue, 1986-71
administrators, 1982-37B, 1982-37C, 1982-
85, 1984-03, 1984-06, 1984-47, 1984-
96, 1985-02, 1985-23, 1986-82
academic libraries, 1982-08, 1982-11,
1982-14, 1982-15, 1982-21, 1982-27,
1982-42, 1982-109, 1983-08, 1983-
11I, 1983-11J, 1983-20, 1984-44,
1983-71, 1983-78, 1984-14A, 1984-
15, 1984-21, 1984-24, 1984-62, 1984-
68, 1984-81, 1984-90, 1984-92, 1985-
04, 1985-09, 1985-33, 1985-35, 1985-
49, 1985-80D, 1985-80F, 1985-80H,
1986-02, 1986-03

library schools, 1983-87, 1984-44, 1985-
93
public libraries, 1983-12, 1983-25, 1984-
07, 1984-82, 1985-80G
AECT *see* Association for Educational
Communications and Technology
affirmative action, 1982-05, 1982-20B,
1982-20C, 1982-20E, 1982-130, 1983-
09A, 1983-09B, 1983-09C, 1983-38,
1983-40, 1983-72, 1984-38, 1984-78,
1984-79, 1984-88, 1984-120, 1985-31,
1985-80D, 1986-24
ALISE *see* Association for Library and
Information Science Education
Alldredge, Noreen, 1983-37
American Association of Law Libraries,
1982-53, 1982-97, 1986-78
American Council on Education Fellows
Program, 1984-81
American Freshmen: National Norms for
Fall 1982, 1983-46
American Library Association, 1982-131,
1984-103, 1984-104
1982 Annual Conference, 1982-78, 1982-
98, 1982-102, 1982-103, 1982-104,
1982-105, 1982-106, 1982-110, 1982-
114, 1982-116
1982 Midwinter Meeting, 1982-65
1983 Annual Conference, 1983-67, 1983-
81